# The State and the Visual Arts

# The State and the Visual Arts

## A discussion of State intervention in the visual arts in Britain, 1760 – 1981

Nicholas M Pearson

The Open University Press
Milton Keynes

The Open University Press
A division of
Open University Educational Enterprises Limited
12 Cofferidge Close
Stony Stratford
Milton Keynes MK11 1BY, England.

First published 1982

British Library Cataloguing in Publication Data

Pearson, Nicholas M.
  The state and the visual arts.
  1. Art patronage — Great Britain
  2. State encouragement of science, literature and art — Great Britain
  — History
  I. Title
  709'.079     N8846.G/

  ISBN 0-335-10109-7

Phototypeset and printed by Avon Litho Ltd, Stratford-upon-Avon, England.

# CONTENTS

# Preface

Over the past decade there have been recurrent debates and controversies about the effects and implications of particular schemes and policies as pursued by a particular museum of art, an arts council, one of the regional arts associations or an art school. Thus, the collecting policies of the Tate Gallery have come under scrutiny; the Arts Council's *Hayward Annual* exhibitions have aroused fierce debate; and the Arts Council of Great Britain's Awards scheme provoked such negative reactions that it was finally abandoned altogether.

In this book I have sought to go behind the effects of particular schemes and programmes to examine some of the basic assumptions, patterns and relationships that have underlain State policy towards the visual arts as it has developed over the last two centuries.

The book is not intended as a 'history' of what has happened over a two hundred year period. Historical material is drawn on to illustrate points and arguments but in no sense is the book a comprehensive and sequential account of all the things that have happened in the field — or even of all the major events that have taken place. It is hoped, however, that the analysis presented offers a framework and a mode of enquiry in terms of which the comprehensive history of the relationship between art and the State in Britain can be understood. Moreover, it is intended that the historical material drawn on should illuminate for the reader not only the general principles underlying the organization of the State today, but, more particularly, the reader's own experience of working with, working in or relating to one of the many contemporary official bodies concerned with the visual arts.

I suggest the need for a comprehensive debate over the role of the State in relation to the visual arts, and the need for a 'political' understanding of the use of State power in the visual arts. I do not present any firm conclusions as to what should be *done*: that is not the point of the book. But I do argue strongly the need for a more open and critical public debate over whatever *is* done. The book is not a set of solutions or proposals. It is an invitation to a debate and an argument.

The book grows out of material presented as part of a Ph.D thesis to the University of Durham. That thesis was worked on while I was a research student at that University, and was completed while employed as a Tutorial Assistant at the University of Leicester.

Subsequently the argument has been informed and extended not only through further reading, observation and conversation, but through the experience of working in a museum, teaching in an art college, working on a national survey of the economic positions of visual artists, serving as a member of the Art Committee of the Welsh Arts Council, and conducting a survey of art galleries and exhibition spaces in Wales for the Welsh Arts Council.

Nicholas M Pearson
1 December 1981

# The State and Art

The history of the visual arts in Britain is intimately bound up with the history of the British State. Just as education, welfare, industry or leisure cannot be understood without a consideration of the policies, finance and frameworks set by the State, so the visual arts in Britain cannot be fully understood without a consideration of the role and function of the State.

This book is an examination of aspects of the State's involvement in the visual arts in Britain over a two hundred year period. The book is not so much a history of the State's involvement over that period as an exploration of some of the arguments and assumptions lying behind its increasing involvement. Specifically, something of the continuities in State policy are indicated, particular attention being paid to the ways in which State involvement has structured and shaped the nature and practice of the visual arts as part of a public culture.

## The State

'The State' is a political concept: it describes a political formation, and is part of the vocabulary of political life. The meaning of the term is constantly disputed. In Britain, particularly in the twentieth century, the word has been used in an increasingly negative sense. Political parties tend to distance themselves and their actions in Government from the idea of the State. They tend to set the idea of 'the State' in antithesis to concepts such as 'freedom' and 'individuality', and while in Government tend to use terms such as 'public', 'national', 'community' and 'social' to describe actions and initiatives involving State power and organization. The difficulty of the idea of the State, however, is indicative of its centrality to an understanding of our political, social, economic and cultural life. In fact it is the very ambiguity of the idea of the State in British political and cultural life that is central to the power and influence of the State in Britain today. The ambiguous nature of the State is crucially bound up with the complexity, apparent flexibility, and real strength and immutability of the British social, political and cultural system.

The most simplistic view of the State sees it in terms of force: the force of

armies and the police. Few States, however, have existed for long on the basis of pure and unadulterated force. Force is usually regularized and ordered through the existence of law — law which restricts and controls the arbitrary use of force and power according to publicly established criteria and conventions.

Law, however, is more than simply a set of rules and conventions. Law is presented and argued for in terms of an appeal to a morality — an appeal to a set of values and norms which at least the more powerful sections of a society will accept as, in some fundamental sense, just and right. Law cannot exist without the threat of force but, at the same time, it rarely exists without appeal to moral or spiritual values which legitimate both the law and the use of force.

Moral and spiritual values are crucial to the existence of the State, for it is by appeal to these that the State exists as a form of authority — as something which commands, rather than simply enforces, obligation and respect. The State cannot command obligation and respect without the existence of force, but it can rarely exercise force without the regulation of law, and an appeal to higher moral and spiritual values.

In this sense the State is a moral force. It is presented as an expression of the 'nation', the 'society', the 'community'. After the split with the Roman Church the British Monarch, as Head of State, became also head of the Church, moral and spiritual power being thus explicitly brought together with the power of the State. The former legitimated the latter, and the latter strengthened and reinforced the former.

In examining, therefore, the role of the British State in relation to the visual arts we are looking at one of the ways in which the British State has become involved in developing and reproducing moral concepts and a moral authority — for the culture of the visual arts has become centrally bound up with forms of morality and appeals to spiritual values and sensitivity.

A common confusion in usage of the word 'State' is its conflation with the direct and obvious organs and institutions of Government — that is, in British terms, with national Parliamentary Government, the Civil Service, and those aspects of Government work directly controlled by parliament and the Civil Service. Such a conflation of ideas not only renders the term 'State' superfluous; it makes an understanding of the operations of public authority, power and control in Britain highly confusing. The State is more than Government and the Civil Service: the separation in many countries of the legal system from the administrative system is sufficient to make the point. However, the separation of various forms of authority within the relations of the State goes much further. In Britain, for example, the practical separation of the Crown from Parliamentary Government is important for the workings of the State, for this makes possible a complex set of distinctions between actions taken by Parliament and the Civil Service directly (although under the authority of the Crown); actions taken directly by the Crown, though on the direct advice of Parliament and Government; and actions taken directly by the Crown and largely independently of Parliament and Government.

These distinctions can be illustrated by reference to two art institutions —

the Royal Academy of Arts in London, and the Arts Council of Great Britain. The Royal Academy received its Instrument of Foundation and its Royal title directly from the Crown and, even today, receives a certain measure of its authority from the Crown. The Arts Council of Great Britain, meanwhile, received its Charter from the Crown (and thus was established independently of Parliament and the Civil Service), but the Charter was given by the Crown on the direct advice of Parliament and Government. Finally, the Arts Council of Great Britain receives its annual grant directly from Parliament, (Parliament, of course, acting under the authority of the Crown).

The complexity of the British State, however, goes beyond the divisions and distinctions that can be made in terms of the functions and authorities of Parliament and the Crown. It extends through the divisions and separations between national government and local government; national and regional authorities set up by, but separate from, central Government; the plethora of advisory, official and semi-official committees and institutions set up partly or fully by Government and given partial or full financial backing by Government; and the range of group and individual initiatives and actions given legal or financial backing by Government. The State, in other words, is a complex set of relations which shape and are part of a wide range of economic, social and cultural activities. The State is not a discrete organization or machine. It is a set of practices, relations and forms of authority bound up with many aspects of daily life. It is not a discrete 'thing' that can be specifically identified and described on an abstract or theoretical level. It has to be understood in its particular forms.

This book sets out to look at one form of State — the British State as it has developed since the mid-eighteenth century — in relation to one aspect of life: the culture of the visual arts.

## Art

Just as the State is an elusive concept describable only in and through its particular formations, so also is art.

The practices of painting, sculpting and image-making have long and complex histories within all societies and cultures. But the separate and specific identification of certain practices and particular kinds of image-making as being, in the modern and current sense, 'art', has only a very brief history. As Harold Osborne has noted:

> Through the greater part of human history the so-called 'fine arts' were regarded as handicrafts among others, not distinguished as a class, and . . . art objects like products of human industry were designed to serve a purpose recognised and approved by the society in which they arose.. . . . The purposes of the arts have been extraordinarily various.[1]

In the Middle Ages a distinction was drawn between the 'liberal' and

'mechanical', or 'theorectical' and 'practical' arts — but here 'arts' is being used in a very broad sense quite unrelated to the modern specialist usages as in 'fine' and 'visual' arts. Thus, as Osborne again points out:

> Poetry and the theory (but not the practice) of music were ranked among the 'Liberal Arts', pursuits proper for an educated man and a gentleman; sculpture and painting belonged to the 'sordid arts' and their practitioners were classed among the manual workers or *artisans* and were often members of the craftsmen's guilds. . . . As a very broad generalisation the 'practical arts' were considered to be those which involved a manual skill and the 'theoretical arts' those which were thought of as belonging to the mind, as depending on the exercise of reason or the acquisition of scholarship.[2]

'Art' comes from the Latin *artem* meaning 'skill'. The distinctions pointed to by Osborne are distinctions between different kinds (and implied levels) of skill: between the 'mental' (or higher level) skills, and the 'manual' (or lower level) skills. Most human activities involve some 'skill', and are (or were) in this sense 'arts'. And in fact in the Middle Ages a broad general distinction was drawn between that of the world occasioned by human skill or agency (i.e., that which is 'artificial') and that occurring without human skill or agency (i.e., that which is 'natural').

The root meanings of art are still, in a vestigial sense, current in the English language. The *Concise Oxford Dictionary* (1964) includes, for example, the following:

> *artefact* a product of human art and workmanship; a product of prehistoric art as distinct from a similar object naturally produced.
> *artful* cunning, crafty, deceitful.
> *artifice* device, contrivance; skill.
> *artificial* made by art; not natural.
> *artisan* mechanic, handicraftsman.

Even the word 'Art' itself is defined as;

> skill, esp. human skill as opposed to nature; skilful execution as an object in itself; skill applied to imitation & design, as a painting etc; . . .

while 'Artless' is defined as;

> unskilled, uncultured; clumsy; natural; guileless, ingenuous . . .

The modern and specialist meanings of 'art' and 'artist' were not fully established and consolidated in English until the late nineteenth century. However, as Raymond Williams points out, it was in relation to painting, drawing, engraving and sculpture as a group of skills that, in the late

4

eighteenth century:

> ... and with special reference to the exclusion of engravers from the new Royal Academy, a now general distinction between artist and artisan — the latter being specialised to 'skilled manual worker' without 'intellectual' or 'creative' or 'imaginative' purposes — was strengthened and popularised.[3]

Williams states that the 'emergence of an abstract capitalised Art, with its own internal but general principles, is difficult to localise'. He notes several late eighteenth century uses, but suggests that it was only in the nineteenth century 'that the concept became general'. Its establishment was thus related to the development of the ideas of 'culture' and 'aesthetics'.

The roots of the modern role of the artist can be traced back to the Italian Renaissance, the break up of the medieval guild system, and the arguments made for the intellectual status of the painter and sculptor by, among others, Leonardo. However, it was only during and as part of the industrial revolution that a more elevated and specialized role for the painter and sculptor *as artist* became firmly established. These developments were both a part of the increased division of labour (artist being distinguished from scientist, technologist, artisan, skilled worker, etc.) and a reaction against the processes of industrialization, the spread of utilitarianism and the growth of commercialism.

The social construction of the idea of 'art' and 'artist' was, of course, far more than simply the specialization of a role and a practice, and the absorption of particular traditions associated with painting and sculpting into the umbrella concept of 'art'. As Raymond Williams notes, 'art' and 'artists', within the increasingly specialized division of labour, came to acquire;

> ever more general (and more vague) associations, offering to express a general *human* (i.e., non-utilitarian) interest, even while, ironically, most works of art are effectively treated as commodities and most artists, even when they justly claim quite other intentions, are effectively treated as a category of independent *craftsmen* or *skilled workers* producing a certain kind of marginal commodity.[4]

The power and force of 'art' as a respected, valued and elevated social phenomenon flows from and is intimately bound up with the very 'general', 'vague', *human* and non-utilitarian values ascribed to it. It is its very lack of an obvious (and utilitarian) function that is held to demonstrate its importance.

A painter or a sculptor is a person who paints or sculpts. The person is defined by the activity. The painter makes paintings, and is self-evidently a painter if observed in the act of painting. As the categories of painter and sculptor were absorbed into the wider and more general category of 'artist', however, the direct link between the practice and the definition of the person began to weaken.

5

In terms of the pre-eighteenth century, and particularly in terms of the pre-Italian Renaissance, understanding of painters and paintings, the qualities and character of the painter bore no necessary relationship to the qualities of a painting. As Plutarch commented in *Pericles*: 'It does not of necessity follow that, if the work delights you with its grace, the one who has wrought it is worthy of your esteem.' The painter was a skilled worker, and, as such, was of no greater or lesser value than any other skilled worker.

However, as the painter and sculptor became 'artist', the qualities ascribed to 'art' (creative, imaginative, special, and expressive of *human* as opposed to utilitarian values) were increasingly also ascribed to the artist. The specialness of the work became in part a function of the specialness of the person.

This shift in emphasis from the person being defined by the activity (a painter is somebody who paints) to the activity being defined by the person ('art' is something created by 'artists') is discernible in the Romantic movement and before; but it reached its logical conclusion in this century. An oft-quoted illustration is Marcel Duchamp's successful submission of a urinal to an exhibition. The urinal became an art object, and a statement about art, because of being chosen by an artist and accepted into an art exhibition. Person and context defined the object; the object did not define the person.

Duchamp's gesture was one of a number of critical moments in the dislocation of the idea of the artist from its previous tighter relationship with the traditions of painting and sculpting. The varieties of media, activities and philosophies engaged in, pursued and used by some artists today flow from and are dependent upon the shifts in meaning from the person being defined by the activity, to the activity being defined by the person.

In 1970 the transformation in definitions was enshrined in the Coldstream-chaired *Joint Report of the National Advisory Council on Art Education and the National Council for Diplomas in Art and Design*. It was noted:

> We do not believe that studies in fine arts can be adequately defined in terms of chief studies related to media. We believe that studies in fine art derive from an attitude which may be expressed in many ways. [5]

The report was reflecting, consolidating and developing changes in British art education that had been introduced in the 1960s when, with the introduction of the Diploma in Art and Design, the education of art students in terms of an introduction to specific and traditional skills was finally abandoned in favour of more exploratory and student-centred methods of education. However, the key word in the quotation is 'attitude': 'studies in fine art derive from an *attitude*'. It is not the activities students engage in that are to define them as art students, but their approach to, thoughts about, and attitude towards whatever they are doing. Here we see what Williams referred to as the 'ever more general (and more vague) associations' becoming paramount. Art is in the mind of the maker; it is not necessarily discernible in the observable qualities of that which is made or done.

In seeking here to unravel and display some of the ambiguities of what art,

as a social definition and practice, has become, I am not intending in any sense to necessarily belittle or devalue what artists do. To seek to deconstruct and to locate an historical and social phenomenon is not necessarily to suggest the irrelevance or unworthiness of the phenomenon.

If we are to examine something of the relationship between art and the State, it is necessary to understand something of the social and historical nature of both phenomena. In general, in the rest of this book, while I present material concerning both the State and art, the analysis concentrates on the nature of the State, rather than on the nature of art. It could be all too easily assumed that art in itself is an unproblematic phenomenon with which, for various obvious reasons, the State has become involved.

In fact not only is art a highly problematic phenomenon, but it is precisely during the period covered by this book that the modern, ambiguous and powerful definitions and understandings of 'art' were established. It is not possible to say with any precision to what extent the intervention and support of the State were critical in consolidating and promoting some of the changes and transformations indicated; but obviously institutions including the Royal Academy, the various national museums of art, the art schools and the arts councils have played and are playing an important and pivotal role in maintaining and reproducing some of the more socially, culturally and educationally powerful and influential values ascribed to art. State intervention has not simply *supported* art, in the sense of lending credence and succour to a pre-given and value-free set of practices. It has radically affected what art is, how it is understood, and how it is practised. Particular tendencies, assumptions and values have been marginalized and neglected. The State is not and cannot be morally neutral.

The visual arts have come to have ascribed to them all kinds of moral, spiritual, human and mystical values, associations and meanings. The foundations of art in human making and experiencing are often lost in the rhetoric and culture that surrounds, defines and interprets art. State intervention has played an important and powerful part in developing and reproducing these values and associations, and in making art into a thing that is, in various ways, un-popular and anti-popular.

# The Royal Academy of Arts in London

State patronage of the visual arts in the sense of the State or Head of State using architecture and visual imagery to promote their authority and power has a history as long as the history of governments and States. The Royal Academy was, therefore, in no sense, the first example of State involvement in the visual arts in Britain, let alone in the world. The foundation of the Royal Academy was, however, the first major action by the British State in promoting the visual arts as part of a public culture according to a model and form of State intervention in the arts that was to become firmly established over the next two centuries. The Royal Academy was, to use an ugly modern phrase, the first Quasi-Autonomous-Non-Governmental-Organization (quango) in the visual arts.

The Royal Academy was a forum for the ideological and material production of the fine arts in Britain in the late eighteenth, nineteenth and early twentieth centuries. The existence of the Academy was important for defining the nature of the fine arts, and setting the conditions for opposition to the established and establishment definitions of art. Today the Royal Academy is generally seen as being a 'private' institution, though with a 'public' role. This sense of the Academy as both private and public at the same time has been fundamental to its strength and importance as a major national institution for the visual arts — and this ambiguity follows directly from the way the Academy was founded in relation to the State.

The Royal Academy of Arts was established in 1768 by an Instrument of Foundation granted by the King. The Instrument of Foundation established its form, functions and regulations, gave it its 'Royal' title, and established its relationship to the Crown.[6] The Academy opened in 1769, and its first exhibition was held in Lambe's Auction Rooms in Pall Mall. The exhibitions continued in Pall Mall for ten years but meanwhile, in 1771, the King granted seven rooms in the Old Somerset Palace of Inigo Jones to be used as the School of Drawing, Library, Council Room and lodgings for the keeper.

The new Somerset House was ready in 1780, and the whole Academy was transferred to the new site facing the Strand. Up to this point the King had been making up financial losses incurred by the Academy, these totalling about £5,000; from 1780 onwards, however, the Academy was financially self-sufficient from its exhibition receipts.[7]

The Academy remained in the premises provided by the King at Somerset House until 1836, when it moved into part of the new building in Trafalgar Square erected to house the National Gallery — a building put up by the Government at 'public' expense.

By the 1860s the Government wished to use the whole Trafalgar Square site for the National Gallery and it therefore gave the Academy a 999-year lease at a nominal rent on Burlington House and a site to the north of Burlington House, the Academy to erect further buildings on the new site at its own expense.

This brief sketch of the early history of the Royal Academy enables us to make several points.

The Instrument of Foundation of the Academy constituted the giving of official recognition and support by the Head of State (the King). The granting of the Instrument, however, was an action that, in certain terms, could be seen or interpreted as being not to do with the State: this follows from the possibility of the British Monarch acting and existing in several capacities.

In his first capacity the Monarch is Head of State *through parliament*: the King's or Queen's Ministers and subordinates take actions and promote legislation through Parliament, these actions and laws being validated by the Monarch.

In his second capacity the Monarch can take actions on his own behalf, as in signing the Instrument of Foundation for the *Royal* Academy. This action is a direct transaction between the Monarch and the organization, and no rights of legitimate interference in the organization are bestowed upon Parliament through such a transaction.

In his third capacity the Monarch exists as a private person with a considerable private fortune at his disposal. A large part of this wealth relates, of course, to the Monarch being Monarch — head of the Royal Family — but the use of some of the wealth can, nevertheless, be 'private'. In this capacity the Monarch can bestow funds or premises on another person or organization, as was done with the Academy.

Rather crudely we can summarize these three different ways in which the Crown exists by saying that in his first capacity the Monarch is a 'public Monarch'; in the second capacity he is a 'private Monarch'; and in the third capacity he is a 'private person'.

The Royal Academy related to the Crown in two of the above ways: it was granted a 'Royal' title with Royal support (second capacity); and it was given premises and limited finance. Any rich person could have done the latter (acted in the Monarch's third capacity); the wealth of the Monarch (despite this wealth being related to the Monarch being Monarch) is therefore only a reinforcement for the first and second forms of existence of the Monarch.

Part of the subtlety of the British political system is that when the Head of State acts in the second and third capacities as described above, this is sometime interpreted in political terms as being not to do with the State, for it is not directly to do with Parliament and the Civil Service. The ideological strength and importance of the Royal Academy of Arts in the nineteenth century (when it was at its most powerful) relates, therefore, to the possibility

of the Academy being seen as an independent and private institution, while at the same time being established and supported by the Head of State as Head of State — without, of course, any direct reference to what we can call the machinery of State (Parliament, the Civil Service, 'public accountability', etc.).

The importance of the Monarchy, therefore, is that it is able to be seen as 'State' and 'not-State' at one and the same time. Hence, the Royal Academy could take to itself some of the authority and legitimacy of being 'State' and 'official', without at the same time being seen as an instrument of Government. The Academy was in the classic position of a major modern day quango — of the State, while not being directly of Government.

## The State, the Academy, and taste

As it was, in essence, a quango the nineteenth century Academy was always ambiguously related to Parliament and Government. It was an official body, a national authority, it had a public role and public functions; but it was at the same time 'private' and 'independent' (of Parliament and Parliamentary Government). In 1836, when the Academy moved from Somerset House (a Royal building) to part of the National Gallery building (a Government or 'public' building), this was taken by some public figures and members of parliament as a pretext for public or parliamentary scrutiny of the Academy as a public authority, but such public accountability was always resisted. Thus, for example, Lord Lyndhurst, speaking in the House of Lords in 1859, asserted that the Royal Academy held its premises in the National Gallery 'not of the nation, but of the Crown, and at the pleasure of the Crown'.[8]

However, despite resistance on the part of the Academy to public scrutiny, a succession of public enquiries was held into its role and functioning throughout the nineteenth century, and the evidence taken for these enquiries makes fascinating reading. Daniel Maclise, RA, commented, before a Royal Commission on the Academy in 1863, on the succession of State enquiries into the Academy:[9]

> I often wonder why these inquiries are being constantly made. During the whole of my career there has been a series of inquisitions as to its [the Academy's] proceedings, which appear rather extraordinary to me, and the same thing happens over and over again. Even the questions which were answered 15 or 20 years ago crop up again. These seems to be a new race of inquirers who make the same suggestions, and ask us the same questions, requiring us to give answers which have been given already.[10]

In a sense Maclise was right: there was a new race of enquirers and investigators. But they were not mere meddlers. The mid-nineteenth century context was the most rapidly expanding and changing industrial society in the world. This context was both exciting and alarming. It was alarming because

the changes taking place were so rapid and so vast. The State responded to and was part of the changes taking place. The direct machine of the State was expanding rapidly through the construction of organizations, laws, inspectorate systems and information gathering committees and enquiries in many fields.

Investigations of the Academy and of other matters to do with public art were part of the process of gathering information and seeking to affect and control a rapidly changing society. Investigations of the Academy came under the heading of 'public taste': public taste was a concern of Government and the State, for public taste related to public morality, hence to public behaviour, and public order. One of the requirements of the 1863 Royal Commission set up to 'inquire into the present position of the Royal Academy in relation to the Fine Arts' was to assess measures required to render the Royal Academy 'more useful in promoting Art and in improving and developing public taste'. 'Taste' could elevate a man from his lowly status; as Alexander Beresford Hope, MP, said before the 1863 Royal Commission: 'Men who were mere workmen a few years ago are getting more and more artistic with the growth of public taste.' Having 'taste' and 'growing more and more artistic' could imply an idea of being 'civilized' — being of or like the middle and upper classes. The State's concern with public taste can easily be translated into a concern with incorporating people into specific forms of life, particular ways of behaving and thinking. The idea that the Government should seek to influence and control people's thinking and behaviour is antithetical to the ideas of freedom and individuality which are fundamental to the British political system. The idea that the State, should be deeply involved in developing and shaping public taste, knowledge and education is, however, also fundamental to the British system.

While at one level the British State in the nineteenth century was concerned with public taste as it related to public morality and public behaviour, there was also an assumption that raising public taste would improve consumer discrimination, and this, combined with an improvement in manufacturing standards and techniques, would place Britain in a better competitive position in international markets. This is an argument we shall consider more fully in discussing the Government art and design schools.

## The necessity for and dangers of State control

It is now commonly held that art is, of all activities, one of the freest, most individualistic, and least amenable to regulation and control. In terms of this view of art, the long history of State involvement in the visual arts is surprising. What is not surprising is that the arguments for State involvement in the visual arts have often been ambiguous and convoluted, suggesting forms of State involvement in and support for the visual arts that lent the authority and power of the State to particular views of art, while at the same time appearing to minimize the role of the State in art. Such arguments were made to the Commissioners of the 1863 enquiry.

David Roberts, RA, as witness to the enquiry, was asked whether a body embracing the best 'sculptors, architects and painters, and also non-professional members, might not be of use as a body of *referees* on questions of public monuments and improvements in the metropolis and elsewhere in the Kingdom.'[11] The suggestion was essentially that a central authoritative aesthetic advisory body be set up: a body that could in a sense direct public taste, while not directly controlling it. 'Referee' is the interesting word, for it embodies the idea of some group to whom reference could be made, rather than a Ministry or authority who would give or take instructions. The suggestion was that the Academy should become such an advisory body, the semi-official authority of the Academy thus being carried forward into the new role.

During the witness of Alexander Beresford Hope, MP, the idea of a central regulating body was again discussed, at some length. Beresford Hope was of the opinion that the art movement of recent years did require 'some central regulating influence', but he was highly antagonistic to what he called 'a strong movement going on' the effect of which 'would be to place that central regulating influence under the direct and unchecked control of the Government, and make in fact a simple department of the state.'[12] Beresford Hope stated that such a development would be 'very dangerous indeed in its influence'.

However, Beresford Hope was far from antagonistic to the idea of State involvement in the visual arts *per se*. He wanted Government backing for art without this leading to Government control of art.

> While it is well that whatever Government attempts on behalf of art should be more systematically and better regulated than at present, it would be fatal if this were to lead to free opinion and free work being subordinated to bureaucratic authority.

Thus he set the idea of direct Government and State involvement in art in opposition to the idea of freedom — the lack of which would be fatal for art. But, at the same time, Beresford Hope wanted some 'central regulating influence' and a greater systemization and regulation of Government backing for the arts. Beresford Hope's reconciliation of the conflicting desires to have not only a central authority for art with Government backing, but also freedom from Government involvement in art, was made clear when he later stated to the Commissioners that 'self-elected corporations keeping the administration in check is of the genius of the English constitution.'[13] The basis for this statement had been made clear earlier in his witness when he had said that the regulation of art and culture which he saw as desirable should be carried out by: 'Some body that should be elected by the artists and lovers of art, and which should be independent of the changes of administration and political under-currents.'[14] While being 'independent', however, such a body should, in Beresford Hope's view, be able to utilize State power where necessary; thus he argued:

> There ought to be a department of the State, which should

combine the artistic half of the Vice-President of the Committee of Council on Education, and the artistic half of the Board of Public Works. There should be, in short, a Minister of Arts and Works.[15]

Crucially, however, this new Minister should not be free to do as he pleased:

When this Department of Arts and Works has been created we shall then want to keep the new minister in check by a central regulating body for the various art movements of the country, which should be independent of the Government of the day. This central body I should look for in the Royal Academy, changed and strengthened.

This is a subtle arrangement, and worth looking at closely. The careful counterbalancing of the arrangement whereby an independent body with a professional membership acts in relation to and with the backing of Government and a specialist Ministry is certainly, in Beresford Hope's words, 'of the genius of the English constitution'; it is fundamental to it. Large areas of Government work are today carried out under such an arrangement. Beresford Hope wanted the independent professional body to be elected. That, today, is rare. But that aside, Government involvement in tourism, the arts, industrial development, university finance, research and many other fields, is carried out under a system whereby semi-'independent' bodies staffed or advised by 'professionals' execute and develop Government policy and spend Government money — with the back up of specialist Ministers and departments of Government.

The subtlety of the arrangement proposed for art by Beresford Hope is that it combines the power and authority of the State with the independence and authority of a professional meritocracy. Central to the proposal is that element of voluntary acceptance of control and authority fundamental to the workings of the British State; control and authority has all the appearance of being separate from the State and independent of Government — and yet in reserve and supportive of it are the power, finance and authority of Government.

Beresford Hope's proposals were not implemented in the mid-nineteenth century. It was to be another hundred years before there would exist both a Government Minister for the Arts *and* a quasi-autonomous body exercising a central regulating influence on art, this body (the Arts Council of Great Britain) including professional and non-governmental advisors on its various panels and committees.

The basis of the system already existed, however, in the relationship of the Royal Academy to the Crown and (through its occupation of 'public' buildings) to Parliament; and the separation of State powers between national government, local government, semi-autonomous bodies and private individuals was to be fundamental to the development of State policy in other matters to do with art in the nineteenth century: the Government art schools, museums of art and various major national exhibitions.

13

# The Government and Art Education

Throughout the nineteenth century the Royal Academy was seen as representing the highest level of art: it catered, as an 'independent' institution, for what was seen as the best in fine art, and it maintained, through its existence, the ideological and spiritual freedoms of art.

Meanwhile the State, faced with the problems of industrializing capitalism, set up what can be called a 'second level' system of art education directly controlled by the State with the aim of producing both design technicians and a general raising of the level of public taste.

While direct control of the Royal Academy by Government was generally considered to be undesirable, direct State control of the new national art and design education system was a different matter. For, while the Royal Academy catered for pure art and for the artistic élite, the national State system was to deal with applied art and with the taste of the general population. This combination of freedom at the Academy level and control at the mass level is important, for in its freedom and independence the Academy thus fulfilled an ideological role: it represented unfettered creativity. In relation to this the State-controlled art education system established in the 1830s could be seen as not so much State control of art, as the application, in a State-controlled system, of the principles freely developed by free men (the pure fine artists) outside the State-run sector. The artisan in the State education system was not to be offered 'art'; rather he was to be offered the techniques already developed by artists. In this way 'taste' (morality, right thinking and commercially useful skills) could be propagated throughout the population.

Such a separation of the idea of fine art, and the freedom seen as necessary for its development and practice, from applied art, design and other manufacturing activities, is fundamental to the way the ideology of the fine arts has developed and been institutionalized. In one form this separation was expressed by Sir Joshua Reynolds, first President of the Royal Academy when, in his first *Discourse* at the Academy he remarked that:

> An institution like this has often been recommended upon considerations merely mercantile. But an academy founded upon such principles can never effect even its own narrow purposes. If

it has an origin no higher, no taste can ever be formed in it which can be useful even in manufactures; but if the higher arts of design flourish, these inferior ends will be answered of course.[16]

## The demands for a State art education system

A major step in establishing a State-run art education system had come with the setting up, in 1835, of a Parliamentary Select Committee on the arts and their connection with manufactures. This Committee was set up on the motion of William Ewart, MP for Liverpool:[17]

> To inquire into the best means of extending a knowledge of the Arts and of the Principles of Design among the people (especially the manufacturing population of the country); also to inquire into the constitution, managements and effects of institutions connected with the arts . . .

Ewart's success in having the Committee established was due to a coalition of various interests and arguments. Some people believed in the extension of art education as such; others saw art education in terms of a general availability of useful skills and knowledge; a strong group saw an extension of art education in terms of the economic advantages for Britain following from the development of consumer discrimination and manufacturing standards.

The Society for the Encouragement of Arts, Manufactures and Commerce[18] had been involved in these various issues since its foundation in 1754. As early as 1758 it had run prize competitions for designs in weaving, calico-printing, cabinet making, 'or any other Mechanic Trade that requires Taste'. This competition, located within the area of 'applied arts' had met with a poor response. On the other hand competitions for drawing prizes had attracted many entries, and a long list of distinguished artists received their first public recognition through the Society.

Benjamin Robert Haydon,[19] the nineteenth century historical painter, was one of the most powerful individual campaigners for State patronage of the visual arts. There was comparatively little public art in the early nineteenth century, and what there was tended to be official portraiture in civic buildings and naval establishments. Haydon campaigned for civic paintings appropriate to civic buildings and marine paintings in marine establishments, and so forth. His patron, Sir George Beaumont, gave Haydon access to many prominent men of the day, Haydon carrying his arguments in person as far as Melbourne, the then Prime Minister.[20]

William Ewart, MP, was one of Haydon's most consistent supporters. A champion of free libraries, the abolition of capital punishment and the creation of public museums and art galleries, Ewart believed that the Royal Academy had no intention of carrying further the public promotion of art and design — hence the need for the development of an alternative State system.

The Select Committee established as a consequence of Ewart's 1835 motion

recommended: that a Normal School of Design should be set up in London; that provincial schools should be assisted by grants; that museums and galleries should be formed; and that sculpture and painting should be used to embellish public buildings.

The recommendations on design education were accepted, and their implementation was put into the charge of the Board of Trade, with Poulett Thomson[21], MP for Manchester, as President. Thomson obtained a parliamentary grant of one thousand and five hundred pounds for the venture.

## The beginnings of the State system

Poulett Thomson, as President of the Board of Trade, set up a Council to administer the new schools of design. The Council was to administer total national policy and to it were recruited manufacturers, artists and amateurs of art, with Lord Colborne[22] as Chairman. The artists who were to serve on the Council were recruited, quite naturally, from the most respected and respectable artistic body of the day — the Royal Academy; precisely the body to whose organization and influence Ewart and Haydon were opposed.

The Council took a very narrow view of the possibilities of a public art education, and the teaching system implemented was a very restricted and technical one concentrating on the copying and learning of ornamental motifs. It is said that the first students in the schools were made to sign a declaration that they did not intend to become landscape, historical or portrait painters,[23] and, under John Papworth, first Director of the London school, high art and figure drawing were specifically excluded from the syllabus lest; 'young men might be tempted to leave the intended object to pursue that which is more accredited and honoured.'[24]

While the Government, therefore, had become involved in art education, it had only become involved at a very technical and mechanical level. While on the one hand a form of art education was being offered, access to 'real' art was to be withheld. In a sense the State was offering an access to art without offering an active involvement in the practice of art.

The first twelve years of the design school system were not auspicious.[25] The management and direction of the schools was confused; the results were considered to be poor; and industrialists, whom the schools were supposed to serve through the training of designers, were unimpressed. A Parliamentary Select Committee was established in 1849 to investigate the state of the schools, and its report painted a fairly depressing picture. However, despite the problems of the schools, the Select Committee on the Government Schools of Design felt able to state, in the introduction to their Report, that;

> The witnesses almost all agree in thinking the maintenance of Schools of Design to be an object of *national importance*, and even those who consider the schools to be at present in the least satisfactory state, are ready to admit the value of such institutions to the manufactures of the country.[26]

## Taste, art and technical skill

A problem with the design schools in the 1840s was that they were pulling in several directions, without there being any general agreement on how differing objectives could be brought together. There were three broad views as to what the schools should be doing: the first was that they should be inculcating 'taste' into the general population; the second, that they should train individuals in specific technical skills; and the third, that they should offer broad opportunities for the study and practice of fine art.

There was some broad agreement on the importance of the schools' function in inculcating taste in the general population. Thus the *Report of the 1849 Select Committee on the Schools of Design* commented approvingly that:

> the managers have been right in endeavouring to *raise the taste* of the great mass of artisans, rather than by special efforts to force on a few eminent designers.

We have already remarked on the sense in which the involvement of the State with art is centrally bound up with a concern for public taste — taste as a moral concept rather than as simply an aesthetic concept, this relating to our discussion of the State as, among other things, a set of moral relations and forces.

At one level 'taste' could be defined as an aesthetic concept, and in a neutral way. Thus Burke, in the mid-eighteenth century, defined 'taste' as: 'no more than that faculty, or those faculties, of the mind which are affected with, or which form a judgement of the works of imagination and the elegant arts.'[27] However, while this definition appears relatively straightforward, 'taste' as a moral concept begins to become clear even in Burke's usage when he goes on to discuss the causes of a 'wrong taste':

> The cause of a wrong Taste is a defect of judgement. And this may arise from a natural weakness of understanding (in whatever the strength of that faculty may consist) or, which is much more commonly the case, it may arise from a want of proper and well directed exercise, which alone can make it strong and ready. Besides that ignorance, inattention, prejudice, rashness, levity, obstinacy, in short, all those vices which pervert the judgement in other matters, prejudice it no less in this its more refined and elegant province. These causes produce different opinions upon everything which is an object of the understanding without inducing us to suppose that there are no settled principles of reason . . . men are far better agreed on the excellence of a description in Virgil than on the truth or falsehood of a theory of Artistotle.[28]

There is a confidence that comes near to arrogance in Burke's observations. He is arguing that anyone who has gone through the 'proper and well directed

17

exercises' (the right education and training) and who still disagrees with the given definitions and judgements in aesthetic matters, is either in some way mentally defective (has a 'weakness of understanding') or has not taken the training seriously and attentively (is a person of 'inattention, prejudice, rashness, levity, obstinacy').

While Burke's comments, therefore, are confined fairly strictly to aesthetic matters and the exercise of aesthetic judgements, he identifies lack of 'taste' or a 'wrong taste' fairly clearly with a lack of moral sense and moral discipline. For Burke, therefore, it is not so much taste itself, as the negative of taste which is a moral concept.

It is this sort of conception which was taken up and developed in the nineteenth century in relation to State involvement in the visual arts, with taste being seen as a positive moral good — something which would bring the general population, and particularly the working classes, into order. The Rev. St John Tyrwhitt, in his *Handbook of Practical Art* (published in 1868, and frequently awarded as a Government drawing prize) stressed the moral good attributed to a knowledge of art when he stated:

> All success must be won by hard and systematic exertion, which will save him from lower desires.. . . Nobody expects that the whole of the working classes will at once take to drawing and entirely renounce strong liquor — but many may be secured from temptation to excess.. . . Teaching children good drawing is practically teaching them to be good children. [29]

While, however, there was a measure of general agreement on the moral good of an art or design education, there was far less agreement on the nature and objectives of the education itself. William Dyce, who became Superintendent and Professor of the London school in 1838, explained before the 1849 Select Committee on the Schools of Design that:

> The great question agitated at that time was how the school might be made to operate as a school of design. Some thought that by excluding the study of the human figure and by keeping the pupils to the study of ornament, chiefly architectural, the character of the school might be maintained; others thought that a certain approach to pattern drawing might be introduced into the school. My view was that the students should be taught to make working models and patterns, and in order to do that it was necessary they should understand the various processes of those manufactures to which designs were to be applied. [30]

Dyce, therefore, saw the education as being essentially linked to manufacturing needs and processes. Benjamin Robert Haydon, meanwhile, who had campaigned so actively for the establishment of Government art schools as part of the development of a public art culture, thought otherwise. Speaking to students he declared that 'The Government is determined to

prevent you from acquiring knowledge. You might become artists but you will be denied the power to advance yourselves . . .'[31] Haydon believed the practice of fine art, based on a study of the human figure, to be central to all good and creative work in art or design. Both the human limb and the milk jug, he argued, were regulated by the same principles: all schools of art and design, therefore, should be centred on a fine art training based on the human figure.

While the Government schools were not developing as Haydon would have wished, he did, however, exaggerate his case. Some of the provincial schools were developing in a fine art, rather than design, direction. This resulted partly from the inclinations and interests of staff and students in some of the schools, but also from the form of organization and finance provided by the State.

The early design schools were financed by a combination of central Government grants and local contributions. This combination of central Government finance with local finance in support of projects defined by central Government as useful or beneficial is, of course, typical of many areas of State enterprise and policy in both the nineteenth and twentieth centuries. The combination of central finance with finance from local government or from the local wealthy classes is one way in which the State shapes and directs policy, without appearing to directly control and manage affairs. Approved projects arc assisted and encouraged (both through finance and via legislation) while projects not receiving national encouragement and assistance are less successful — are rendered less viable in relation to those projects receiving assistance.

However, while a system which combines central Government finance with local wealth and contributions at one level enables the State to control and structure events without being seen to directly control or manage affairs, it also means that State actions and initiatives can be peculiarly responsive to the interests of locally based groups of wealthy and influential individuals. This is a factor in understanding State policy and organization in both the nineteenth and twentieth centuries.

Fine art is an activity and tradition which carries and embodies a certain prestige and reputation. Certain local communities (or at least the wealthier sections of them) were prepared to contribute towards the financing of a school within the Government system, but were interested more in a fine art school than in a school committed to industrial design. Thus some schools were supported as largely fine art institutions, despite the objectives set out by central government.

Another pressure on the system towards a fine art provision came from the element of fee-paying middle class women students. The early design schools were generally viewed by the middle classes as 'charity' institutions. The schools were set up to train artisans: they were thus for the poor and were thus inappropriate as places for middle class young gentlemen. Middle class young ladies, however, were a different matter. Particularly where fine art courses were available, these provided an important element in the schools. As they paid fees they were doubly important. Further, such students were often both

able and willing to engage in fund raising activities for the schools, thus further contributing to the finance of the system.

Institutions, therefore, which could provide something of a fine art education for the daughters of local philanthropists were more likely to attract backing from these philanthropists, and would benefit from the fees paid as well as other fund raising activities engaged in by students.

Such pressures, combined with the interests of some of the staff and other students, helped to develop some of the schools, therefore, along a path more fine art than industrial design oriented. This development is illustrated by a comment from Robert Kerr, a textile manufacturer from Paisley who, giving evidence before the 1849 Select Committee set up to investigate the schools of design, noted that the highest branch of teaching in his local school was, 'what they call the fine arts . . . I do not see at all how it is to benefit us'.

## The Governmment art schools: 1850 – 73

Henry Cole, who in the late 1840s was a senior official in the Public Record Office, was a key figure in advising the 1849 Select Committee which investigated the Government schools of design. He had a keen interest in art and design and was to be an influential figure in the organization and success of the Great Exhibition of 1851. Building on his work with the 1849 Select Committee and his involvement with the Great Exhibition, Cole was to take almost complete charge of the Government art and design education system in the period 1852 to 1873. We shall be considering Cole's career more fully in later chapters, discussing particularly his major contribution to the development of public museums of art. Here we shall concentrate briefly on some of the changes and developments that occurred within the State sector of art education under his energetic direction and leadership.

One of the criticisms of the design schools voiced by the 1849 Select Committee had been directed at the inadequate training the students had received prior to their arrival in the schools. This forced the schools to spend more time than was considered desirable on elementary work:

> The teaching of ornamental art necessarily presupposed the students having attained a certain proficiency in elementary studies, and this proficiency few, if any, were found to have acquired, so that it has been necessary to impart it at the beginning of each man's education. The demand for such teaching has been so great in proportion to the means which the schools possess of supplying it, that they have of necessity assumed more of the character of elementary institutions than was originally expected. [32]

Cole tackled this problem by constructing what was essentially a three tier system of art education.

At the lowest level, and outside the art school system as run by the

Government, Cole was successful in having elementary drawing made part of the national elementary education system. In name this national elementary system was 'private' or 'charity' — i.e., the schools were not directly run or managed by the Government, but by private societies, charities and churches. In practice, however, the Government system of grants related to an inspectorate system rendered considerable Government control possible — hence the possibility of including elementary drawing in the curriculum. This is another example of the way in which the State can shape and structure areas of activity without these activities being brought under direct and open Government control.

At the intermediate level Cole attempted to develop the provincial schools as schools of elementary art in relation to the London school, which was to be the pinnacle of the system. Students from the provincial schools were sent for further training to the London school, where they would be trained as art teachers, and sent out again to become teachers in the provincial schools.

Drawing (the basis of a fine art training) was made central to all courses. An emphasis on teaching design to artisans was kept in a modified form — the modification being expressed in the renaming of 'artisan classes' as 'night classes for drawing'. This change in name was in part a recognition of the fact that the students in such classes tended to be clerks, engineers, builders and young architects, rather than 'artisans' in the sense intended.

Overall during Cole's period there was a shift away from the idea of inculcating specific skills into the working classes towards a more general notion of a public education in art. This is an issue which we shall be discussing further in relation to Cole's views on museums and art galleries as a means of public education.

## The Royal Academy in relation to the Government schools

As we have noted, when the Government schools of design were first established in the 1830s, a sharp distinction was drawn in practice between the idea of fine art as practised by members of the Royal Academy and taught in the Academy schools, and ideas of ornamental design and technical skill, which were the province of the Government system.

Under Cole the Government schools adopted a system that was more of an art training, but a distinction still remained between the Academy and the Government schools — a distinction, however, that would be increasingly expressed in terms of the quality or level of work, rather than in terms of the kind of work. Thus Charles Lock Eastlake, President of the Royal Academy,[33] was asked when witness to the 1863 Royal Commission investigating the Academy, whether the Academy had: 'ever considered whether it would be advisable to establish schools in connection with the Academy throughout the country?'[34] Eastlake thought this an undesirable idea. The Academy, he argued, was a central institution for the best students, and he answered simply 'Yes' to the question: 'Do I rightly understand that

21

your theory would be that the Royal Academy school should merely be a school for a superior class of artists who have already passed through preparatory school?'[35]

The witness of Richard Redgrave, RA, was particularly interesting for its discussion of the perceived relationship between the Government sector and the Academy. Redgrave was not only a Royal Academician who had had experience of teaching in the Academy school, but he was also the 'Inspector General of art schools, and referee in art matters generally' in the Government system; at the time of the 1863 enquiry he had been connected with the Government system for fifteen years.

Redgrave was asked to explain to the committee the difference between the education system operated by the Academy, and that run by the Government:

> The Government schools are from the first more elementary than those of the Royal Academy; they begin from the earliest point, teaching children, indeed, in parish schools. They are principally occupied now in training art-teachers; and the teaching has an ornamental direction. I should say that the teaching at South Kensington[36] would principally terminate where the Royal Academy would begin; that is to say, that after having trained the student to a point at which he would be qualified to enter the Royal Academy, from his having acquired a power of drawing, painting or modelling, the instruction thus given is quite in an ornamental direction, preparing designers for manufactures.[37]

In the 1860s it was not generally accepted that the Government had any role to play in providing a free or subsidized education in art for artists. It had a role to play in matters of public taste, and in relation to training designers for industry — that is, Government could intervene at a general moral and aesthetic level, and at an economic level, but not in the direct training of artists. The arguments put forward by Haydon, Ewart and others had not yet won general acceptance in influential circles, yet the Government was, despite itself, involved to some extent in providing something of an art education for artists. This was a growing part of the system it had set up, and some of those who worked in the system were, at least privately, proud of this. This ambiguity is evident in Redgrave's replies to questions. In the piece just quoted he comes near to identifying the training given in the Government schools directly with a continuous development that leads on to the fine art training of the Academy schools: but then he stops, and assets the role of the Government schools in relation to manufactures and ornamental art.

Redgrave emphasized again the differences between the Government system and the Academy schools when he was asked if he did not think it would be a good idea if some of the prizes given by the Royal Academy to their students were not also available to students in the Government system. He stated emphatically;

> We do not wish to make artists of our students. We wish them to

continue as teachers, or in the practice of ornamental art, and if you opened the higher prizes of the Academy, these higher prizes, which are for works of fine art, would lead our students to become artists.[38]

This was the publicly declared policy and function of the Government art education system at the time. Parliament would not have agreed to spending its money on a national education system for training artists, and therefore that was not what the system was doing. The ambiguity of Redgrave's replies continued, however, for in his next statement Redgrave not only revealed his pride in the Government system, but came close to saying that the Government system was giving a better basic training in the practice of art than was available in the Academy school:

> I should say that our system differs from the system of the Royal Academy in one thing, and that is, the continual test examinations. The students are from time to time brought up to examinations, which they cannot shirk, and which we find that they mostly go through satisfactorily. We take our standard so accurately that they all come out with something like the same amount of training. I do not mean to say that we make geniuses, but we give them a thorough knowledge of the reading and writing of art.[39]

Under Cole, therefore, the Government involvement in art education was not only becoming more systematized and ordered, but was gaining in confidence and strength. There are no echoes of the uncertainties and doubts in Redgrave's statement that characterized the Government system in the 1840s. An integrated system was being built up that extended from the main London school through to the lowest levels of elementary education.

# The State and Museums of Art

While Henry Cole's work in restructuring and developing the Government art schools was of great importance, his most innovative work was in the area of art museums — particularly in the development of the South Kensington Museum, one part of which was to become the present-day Victoria and Albert Museum.

Museums of art open to the general public are, in Britain, essentially a phenomenon of the nineteenth century. Temporary exhibitions of contemporary art, in contrast, are a phenomenon of the mid-eighteenth century. The precursors of the permanent public museum of art are both the temporary exhibitions of contemporary art and the private collections of art held by the eighteenth century gentry and aristocracy.

It was the Society for the Encouragement of Arts, Manufactures and Commerce[40] that introduced the idea of temporary exhibitions of contemporary art into Britain, holding one of the first such exhibitions in 1760. This exhibition contained 150 pictures by sixty-nine artists, including Reynolds, Cosway, Richard Wilson, Morland and Hayman. These exhibitions continued annually until 1764, when quarrels among the exhibitors led to the formation of two societies: the Society of Artists of Great Britain and the Free Society of Artists. The former was the direct predecessor to the Royal Academy of Arts.

The establishment of both temporary exhibitions of contemporary art and permanent public museums of art was one example of the process whereby art was made part of a public culture and tradition. The development of Government-supported art schools during the nineteenth century was supportive of and shared in this move towards art as part of a public culture and tradition.

In eighteenth century Britain there was little art generally and publicly available. There was, of course, public architecture, and religious painting and sculpture in churches which had survived the puritan reformation of the seventeenth century; but the main practice of fine art was confined to direct commissions and work for private patrons — the gentry and the aristocracy.

The work of the Society for the Encouragement of Arts, Manufactures and Commerce, as well as the founding of the Royal Academy of Arts, was part of the move towards establishing art as part of a wider public culture — at least

for the emergent commercial and industrial middle classes. It was also part of a process of the professionalizing of artists — the elevating of artists in Britain to a social level nearer to that of their main patrons. Professionalization, however, involves more than social elevation for the practitioner: it also involves the development of a greater self-consciousness, assertiveness, and sense of having a specialist knowledge of and control over a distinctive tradition, body of skills and area of discourse. This self-consciousness and assertiveness is well exemplified in the *Discourses* of Sir Joshua Reynolds, first President of the Royal Academy.

Throughout most of their history painting and sculpture have been seen and practised as craft activities — as among the many manual activities practised by the 'artisan', and having the social status and recognition appropriate to a manual craft. Skill and accomplishment, whether in painting, sculpture, building, book illumination, metal work, or any other craft, were recognized and admired as such in the Middle Ages, but there was no sense in which painting and sculpture, or any other craft activities, were part of an intellectual tradition or discourse.[41]

The idea of painting and sculpture as art and as part of an intellectual tradition and culture has its origins in the Italian Renaissance, developing later in other parts of Western Europe.[42] In Britain the development is essentially one of the eighteenth and nineteenth centuries, and is both interwoven with and the basis for the development of State involvement in and support for art.

The first major public museum at least partly devoted to a collection of art was the British Museum. By Act of Parliament of 1753 a body of Trustees was set up to administer the library, natural history collections, antiquities and works of art bequeathed to the nation by Sir Hans Sloane. The collection was opened to the public in 1759. Admission was, from the first, free, but was by ticket only, visitors being conducted personally round the collection by an officer of the museum. The museum was run essentially as the private collection of a gentleman, to which the public was granted controlled access. It was not until 1879 that all restrictions on free public access to the exhibition galleries of the museum were finally removed.

While the British Museum, therefore, was the first major public museum in Britain, it was not until after the foundation of other major public collections in the early and mid-nineteenth century that it became a fully 'public' museum in the sense that we now understand the idea.

The National Gallery in London was established in 1824. Parliament voted £57,000 for the acquisition of the Angerstein collection, which was first exhibited to the public in the late owner's house at 100 Pall Mall. Having been moved in 1834 to 105 Pall Mall, the collection, and subsequent additions, was finally moved to a purpose-built building in Trafalgar Square in 1838 — the building which was at first jointly shared with the Royal Academy.

Control of the Gallery, as with the British Museum, was vested in a body of Trustees. A keeper, working on the orders of the Trustees, was the principal officer of the gallery. The first Director of the Gallery was appointed in 1855.

This was Sir Charles Eastlake, who was also President of the Royal Academy. As Director he was given full control over the purchase of pictures and the management of the gallery, with the power to override the wishes of the Trustees. (This position was changed in 1894, when the Director, while remaining principally in charge of the gallery was made a member of the Board, responsible with them for policy: still later this position was again altered with the Director being removed from the Board of Trustees).

Other major gallery developments in London in the nineteenth century included the National Portrait Gallery, opened in 1856, and the Tate Gallery, established as an offshoot of the National Gallery in 1896 and later to become a separate gallery in its own right.

These galleries were, and are, all 'trustee' museums; that is, the authority of the State is vested in an 'independent' body of Trustees, and the employees of the museums are not Civil Servants. These museums, in other words, were established according to variants of the 'quango' model — an essentially aristocratic form within which a group of 'independent' public figures act for, and have vested in them, the authority and power of the State. The museums are financed by, but are not of, Government.

Of the major nineteenth century foundations, only the South Kensington Museum was established under the direct control of Government. Unlike the other major national museums, it did not start from the bequest or acquisition of a major private collection. Rather, it grew out of and was built upon the success of the Great Exhibition of 1851 and, certainly in its early years, the growth and function of the museum was understood within a clearly articulated set of educational and cultural policies. Rather than being a private collection open to the public, the museum was seen from the first as being part of a major public campaign to extend the knowledge and understanding of principles of art and design.

Whereas most national museums, moreover, are 'national' only in the sense that they are large, and are based in capital cities, the South Kensington Museum was to be 'national' in the sense that it had established within it a department for making and circulating exhibitions throughout the country — this latter endeavour being an important part of the campaign for the establishing of local museums and galleries throughout the country.

The enactment of legislation dealing with local museums and art galleries, however, preceded the foundation of the South Kensington museums by seven years. That legislation had been 'enabling' legislation — that is, it had permitted local authorities to found museums and galleries, and levy a rate for that purpose, rather than compelling them so to do. It is within this context of enabling legislation that the propaganda effort of the South Kensington museums (and the Great Exhibition from which they grew) was to be so important, elaborating and promoting the idea of museums and art as part of a public culture.

Before considering the South Kensington museums in more detail, therefore, we shall explore the issues surrounding the early legislation for local museums and galleries.

# Local museums of art

The first Parliamentary legislation relating to local museums of art was the Museums Act of 1845. In order to understand this legislation, however, we have to go back to events of the early and mid-1830s, when first, a number of MPs from industrial constituencies, and with interests in various measures of social and educational reform, arrived in Parliament, and second, the Municipal Corporations Act was passed.

The authorities, powers, boundaries and levels of British local government are the product of centuries of development, modification, change and compromise. Even after one and a half centuries of major reform and change, culminating in the local government reorganization of 1974, much of the geographical organization of local government, as well as some of its offices, can be traced through to patterns established in Anglo-Saxon England.

The Municipal Corporations Act of 1835, as with the Reform Act of 1832, was at one level an attempt to adjust the form and administration of government to the changing conditions and pressures of an industrializing society. The Municipal Corporations Act of 1835, however, must also be understood as part of the process whereby central Government has exercised an increasing control over and regulation of local government and activities.

The powers, authorities and procedures of municipal boroughs before the reform act of 1835 were varied to the point where aspects of the system could be called both chaotic and corrupt. The Municipal Corporations Act of 1835 reorganized, structured and defined the powers, responsibilities and authorities of municipal government, and in this sense can be described as a necessary piece of reforming legislation. What the Act also did, however, was to tie the powers and workings of municipal government much more firmly into those of central Government. This is the important point for our discussion of State intervention in the visual arts.

The Municipal Corporations Act defined what municipal authorities were obliged to do, what they could do, and what they could not do. A basic distinction here is between national legislation that is compulsory *vis-à-vis* local authorities, and that which is permissive. Today, for example, it is an obligation upon County authorities to provide and administer an education service; meanwhile both County or District authorities are permitted, but not compelled under law, to provide a museum service.

It is probable that before the Municipal Corporations Act of 1835 any municipal corporation or authority that had had the will would have been in a position to establish a museum of art, just as they could have funded a library or art school, or engaged in various other ventures. The Municipal Corporations Act made national legislation necessary if such corporations were to be able to involve themselves in museums, and the museum legislation of 1845 was the beginnings of a debate that has continued ever since. This concerns the extent to which local government should or should not be involved in cultural matters; whether that involvement should be part of a nationally defined obligation, or simply exist at the level of enabling legislation; and whether local government should be involved in art through

27

the direct management of institutions and organizations, or through contributions to intermediate bodies established on the 'quango' model.

Benjamin Hawes,[43] MP for Lambeth, was one of a number of new MPs who arrived in parliament in the 1830s and who were concerned, in a variety of ways, with public provision and education. Hawes was to be responsible for securing the opening of the British Museum on Sundays, and it was to be by his motion of 1841 that the Fine Arts Commission was established. Earlier he had called for a report on foreign museums and public libraries, this being produced and circulated in 1834.[44]

James Silk Buckingham,[45] another 'reforming' MP, secured in 1834 the appointment of a Select Committee under his chairmanship to enquire into 'the extent, causes and consequences of the prevailing vice of intoxication among the labouring classes of the United Kingdom.' The Select Committee (one of whose members was Benjamin Hawes) recommended in its report on the one hand measures for the control and regulation of public houses and, on the other hand, public provision of athletic facilities, walks, museums and libraries.

This joint recommendation in one report of a series of measures to control and restrict one aspect of life considered undesirable, while providing for and opening up possibilities for another form of life seen as socially desirable is a neat illustration of some of the thinking that has underpinned the development of State involvement in art in Britain. Gramsci, writing on the nature of the State, commented that:

> Every state is ethical in as much as one of its most important functions is to raise the great mass of the population to a particular cultural and moral level, a level (or type) which corresponds to the need of the productive forces for development, and hence to the interest of the ruling classes.

The State's involvement in art is an aspect of this process. Gramsci continued: 'The school as a positive educative function, and the courts as a repressive and negative educative function, are the most important state activities in this sense.'[46] This combination of the positive with the negative is what James Silk Buckingham's committee was recommending. Laws, of course, are not passed which combine in one both the positive and negative functions. Thus James Silk Buckingham attempted to introduce from his committee's recommendations not one bill, but three: one covering control on alcohol; one dealing with public walks, gardens and open spaces; and the third dealing with libraries and museums. But, while laws are passed through Parliament as a series of discrete measures dealing with particular activities, it is the totality of legal and other acts and initiatives that constitutes the shape, direction and form of the State — that reveals a combination of relations, forces and powers that restrict or marginalize certain activities, outlaw some, encourage and assist others, and in total tend to structure and shape the possibilities for individual action and initiative.

James Silk Buckingham's various proposals were brought before Parliament

on a number of occasions, a bill in 1837 combining the proposals on open spaces and facilities with the proposals on public institutions (libraries, museums, etc). William Ewart, who in 1835–6 had chaired the Select Committee on Arts and Manufactures which had recommended not only Government art and design schools but also public museums and art galleries, spoke on behalf of the Bill for public institutions in 1835. In 1839, speaking in Parliament again on public art galleries and other institutions, Ewart linked the State's positive provision of activities seen as wholesome and good with the perceived effect such provision was supposed to have on other, less wholesome, aspects of life, thus again emphasizing the sense in which State provision of art could be seen as tending towards the same ends and objectives as other forms of State control:

> The public libraries, the public galleries of art and science, and other public institutions for promoting knowledge, should be thrown open for the purpose of inducing men merely by the use of their outward senses to refine their habits and elevate their minds.[47]

The various proposals, arguments and reports culminated in the Museums Act of 1845. This Act enabled Councils of boroughs with a population of at least ten thousand people to levy a halfpenny rate for the establishing of a public museum of art and science, and to charge an admission fee of not more than one penny for entry to the museum. In presenting the Bill to Parliament Ewart laid stress on the usefulness of museums in improving industrial design and manufactures and, partly on the strength of that argument, the Bill was passed with little serious resistance. The relative ease of passage of the 1845 Museum Act is interesting, for when in 1850 Ewart introduced a Bill to specifically and clearly include the provision of libraries under the same legislation (the 1850 legislation repealing and supplementing the 1845 legislation) this encountered much stiffer resistance in Parliament. Public libraries were seen in many quarters as simply charity institutions for the poor, and it was not so generally agreed that the State was in business for providing charity for the poor. By contrast museums of art and science were seen as desirable by a number of disparate groups, and for differing reasons. It was generally agreed that they were good for design and manufactures, so there was an economic argument for State provision of or assistance for museums; and it was widely agreed that the structuring and shaping of the national economy was a central concern of the State. It was also, as noted, agreed that museums of art were a moral good, and while many would have argued that the State had no role to play in the provision of leisure or recreational facilities as such, they would have agreed that the State was concerned with the moral state of the nation. Thus where a recreational facility could also be seen as concerning the moral state of the nation, this was a legitimate concern of Government. Meanwhile, of course, museum legislation also elicited the support of those concerned with public education.

Provision of free libraries elicited no such general agreement. There was no

generally accepted economic argument; the educational argument (for those who supported it) was, of course, straightforward; but the moral argument, above all, was in doubt. For, while a museum of art could be, at its best, elevating and sobering, and, at its worst, simply dull, a free library — while at its best (understood in terms of great literature and the classics) it could no doubt be elevating and sobering in the senses expected of art — could also be potentially subversive and unsettling. Knowledge is power, and while the extension of culture and taste could be generally agreed on as 'good things', the free extension of written knowledge was a more difficult question. Despite its more difficult passage through Parliament, however, the library legislation reached the statute book, and both museums and libraries were therefore provided for under the same law.

## The South Kensington Museum

The foundations of both the British museum and the National Gallery were precipitated by events beyond the control of Parliament or any single individual — the foundation of the British Museum by bequests to the nation by Sir Hans Sloane and the foundation of the National Gallery by the availability of the collection of J. J. Angerstein. The foundation of both these museums, therefore, was a response to outside events. The South Kensington Museum, in contrast, was a planned and controlled venture. It was built up, over its first twenty-one years, under the control and direction of one man: a man with a clear and articulated sense of the purpose of the museum and of the wider function of Government in relation to art.

The origins of the South Kensington Museum lie in the success of the Great Exhibition of 1851 — an exhibition whose success was to radically alter the basis and contexts of the debates about the role of Government and the State in relation to art and taste.

The Great Exhibition of the Works of Industry of all Nations was held in Hyde Park in 1851. It was not unique in type, but it was unique both in its scale and its international character.

In France government-supported exhibitions of industrial art and manufacture had been held in 1798, 1801, 1802, 1806 and then regularly from 1819 onwards. In Dublin, similarly, the Dublin Society had set up a triennial exhibition of art, science and manufacture, although until 1850 this was limited to Irish products only.[48]

In Britain the Society for the Encouragement of Arts, Manufactures and Commerce had been involved in exhibitions of industry, art and design since 1761. In the decade prior to the Great Exhibition the Society organized a number of such exhibitions, an exhibition in 1847 being visited by 20,000 people, one in 1848 attracting 75,000 people, and an exhibition organized in 1849 being too large for the Society's own premises.

Prince Albert had been elected President of the Society in 1843, and it was his energetic leadership that contributed much to the establishing of the Great Exhibition and, subsequently, the museums and colleges on the South

Kensington site. Henry Cole, at the time a Senior Official in the Public Record Office, was also a member of the Council of the Society, and closely involved with Prince Albert in developing and organizing the exhibition. Cole, was, as we have noted, also closely involved with the Select Committee of 1849 which investigated the plight of the Government schools of design, and, during the period 1849 to 1852, Cole was also editor of *The Journal of Design and Manufactures,* a magazine he used as a vehicle for his own views on art, design and industry.

While the initial impetus for the Great Exhibition came through the Society of Arts, it was felt desirable, given the scale of the venture, to ask the Government to appoint a Royal Commission to organize and manage the Exhibition. This was duly established in 1850, first via a Commission of Management established by Royal Warrant on 3 January, this being subsequently incorporated by Royal Charter on 15 August, 1850. The group directly responsible for organizing the exhibition was a small committee of five, headed by Prince Albert, and including Henry Cole.

The exhibition was envisaged as a major event in the campaign over matters of taste, design and the industrial arts. For the organizers, therefore, the siting of the exhibition in Hyde Park — in a major space in the centre of the capital city — was a crucial question. This was an issue, however, over which there was much controversy. Thus Prince Albert wrote to Baron Stockman: 'The Exhibition is now attacked furiously by *The Times*, and the House of Commons is going to drive us out of the park . . . if we are driven out of the park the work is done for.'[49] And to the Duchess of Kent he wrote: 'the whole public, led on by *The Times*, has all at once made a set against me and the Exhibition, on the ground of interference with Hyde Park.'[50] Prince Albert, however, was being over-pessimistic: despite tough opposition, Parliament approved the siting of the exhibition in Hyde Park, and the planning of the exhibition went ahead.

The Great Exhibition was held from 1 May to 11 October 1851. It was visited by over six million people, and revenue from admission fees, sales of catalogues and the sale of refreshments, came to about half a million pounds, leaving a clear profit of about £185,000.

The exhibits were presented in terms of a four-fold classification: raw materials; machinery; manufactures; sculpture and the fine arts. The fine art category was a fairly restricted one, concentrating on technical innovations and processes. While sculpture and printing were admissible, oil and water painting, drawing and engraving were excluded unless a particular work demonstrated some new technique or development. Thus, for example, an oil painting would have been admissible not as an oil painting, but if it demonstrated a new development in paint. These restrictions on the fine art category followed from the exhibition being primarily concerned with taste, design and the industrial arts as applicable to manufacturing.

The exhibition was generally agreed to have been a great success. Its objectives had been to stimulate British industry and design, and it was felt that at least the former goal had been achieved. The latter question — the issue of British industrial design — was more difficult to measure. If anything

it was felt that perhaps the French contribution to the exhibition had demonstrated some of the inadequacies of British design. However, the raising of this doubt was, in itself, a good thing for those concerned with design, for, through having brought the question to public attention, they were able to build on this in the future development of Government policy towards art, industry and design.

## The State and the Great Exhibition

The Great Exhibition of 1851 is a fascinating example of the involvement of State power and authority in a venture that related in only a minimal sense to Parliament and Government.

The origins of the exhibition were, of course, private (not to do with the State) in the sense that the idea for the exhibition was developed within a private society. That Society, however, had as its President Prince Albert, a leading and powerful member of the Royal Family, the husband of the Head of State. Prince Albert's Presidency of the Society, therefore, lent to the Society an authority and reputation deriving from his official position, quite apart from any strengths and capabilities he may have had as an individual.

While the initial work for the exhibition was conducted through the organization of the Society of Arts, the organization and management of the scheme was subsequently, as we have noted, taken over by a Royal Commission. This Commission, while embodying in itself the authority of the State as vested in it by the Crown, was, of course, quite separate from the authority and control of Parliament and Government.

Parliament was involved in the exhibition at the level of the debates over whether or not the exhibition should be sited in Hyde Park: this, in a sense 'negative', power was important. But once the Hyde Park site had been granted that was the end of direct Parliamentary involvement. The exhibition was of the State, but not of Parliament or Government.

Earlier we quoted Gramsci's comments on the nature of the State and the relationship he posited between positive and negative educative functions of the State in terms of the raising of 'the great mass of the population to a particular cultural and moral level'. Having mentioned 'the school' and 'the courts' as positive and negative educative functions of the State, Gramsci went on to add that: 'In reality, a multitude of other so-called private initiatives and activities tend to the same end — initiatives and activities which form the apparatus of the political and cultural hegemony of the ruling classes'. [51]

The relationship of private initiatives and activities to State power and authority is very important, particularly in Britain, where so large a part of the work of Government is vested in semi-autonomous bodies and organizations, and where State powere is split between a series of interrelated agencies and institutions under the overall authority of the Crown.

The development of the career of Henry Cole during the period of the Great Exhibition is a neat illustration of this point.

In the late 1840s Henry Cole was a Senior Official at the Public Record Office — that is, he was employed as a senior Government official. However, his interest and involvement in matters of art, taste and the applied arts was chiefly expressed as a private individual, through his membership of the Society of Arts. Meanwhile, of course, in 1849 Cole was involved in giving evidence to, and helping in the organization and writing of, the *Select Committee Report on the Government Schools of Design.* This committee took up many of Cole's arguments, and made recommendations on the basis of these arguments, which recommendations Cole was later able to implement as the most senior Government official in charge of art education.

From his active involvement in the Society of Arts Cole went on to be a leading figure in the organization of the Great Exhibition — an event organized under the authority of the Crown, via a Royal Commission. Meanwhile, between 1849 and 1852, Cole was also editor of a private magazine on design — a forum for his own views, and through which he could put pressure on and arguments to Government, manufacturers and the public. In his opening address in the magazine he declared:

> In conclusion, we profess that our aim is to foster ornamental art in all ways, and to do those things for its advance in all its branches which it would be the appropriate business of a Board of Design to do, if such a useful department of Government actually existed. [52]

As a private individual, therefore, Cole was advocating that there should be a department of the State set up to put into effect the arguments and views held by himself and other like thinkers as private individuals.

Cole's career over this period was thus a mixture of working both within and without the official organizations of the State; his personal initiatives, actions and friendships were as important, over this period, as the positions of authority he held; but they all tended towards the same end, and towards the institutionalization within Government of a department concerned with art.

Crucially, in all this, it was the acknowledged success of the Great Exhibition that made Cole's achievement possible.

## The Department of Science and Art

In 1852 the Government established the Department of Practical Art, under the Board of Trade, with Henry Cole as its General Superintendent. In 1853 the Department was expanded to become the Department of Science and Art, with Cole as Joint Secretary; in 1856 the Department was moved from the authority of the Board of Trade to become part of the Education Department, Cole, from 1858 until his retirement in 1873, being sole Secretary of the Department of Science and Art. [53]

The Department was established both to administer and develop the existing art schools, and to establish 'museums, by which all classes might be

induced to investigate those common principles of taste which may be traced in the works of excellence of all ages'.[54] The basic principle of the Department was stated by Cole before an 1864 Select Committee on Schools of Art as: 'To improve the taste and art-knowledge of all classes of the community, having especially reference to the influence of that taste and knowledge upon the manufactures of this country.'[55] A Museum of Manufactures was established in 1852 on the first floor of Marlborough House. The collection on display included work bought from the Great Exhibition with a sum of £5,000 allocated by the Treasury for that purpose; certain materials acquired over the years by the Government school of art in London; and materials lent by the Queen from her own collections. The specific educational purpose of the new museum was exemplified by its having an ante-room illustrating 'false principles in decoration'.

The museum stayed in the Marlborough House premises until 1857, and while there Cole initiated the Art Library, cheap catalogues, lectures, the evening opening of the museum and the travelling or circulating museum. This latter, established in 1854, involved the circulation of objects and packaged exhibitions throughout the country. Special vans were constructed so that packaged exhibitions could be transferred straight to rail wagons; museum staff travelled with exhibitions, unpacking and arranging them.

The circulation of objects and exhibitions around the country served two purposes: first, it was part of Henry Cole's propaganda for the establishing of local museums across the country under the 1845 and 1850 legislation; second, it was part of his national effort on the level of the development of taste and a knowledge of art. Cole's museum was to be a rare phenomenon among national museums of art: an institution which took its national role seriously, rather than comfortably identifying 'the nation' and 'national provision' with an operation based on the capital city.

In 1857 the museum, which since its foundation had first been renamed the Art Museum and subsequently Museum of Ornamental Art, was moved to its present site in South Kensington, where it became known as the South Kensington Museum. The site had been bought out of the profits of the Great Exhibition. Here the collection was rapidly expanded, major additions including a collection of British paintings. The fine and applied arts section of the museum has since, of course, been renamed the Victoria and Albert Museum — this dating from 1909, when the Science Museum was constituted as a separate museum.

## The 'hard' and 'soft' approaches

State promotion of art and culture can be understood in terms of two forms of intervention, which can be described respectively as the 'hard' and 'soft' approaches.

In the 1830s certain people believed there to be a problem which, expressed very simply, was understood as an insufficient level of taste and art-knowledge among the general population, and, in particular, among the

manufacturing population. Their response was the establishing of schools where a certain level of taste and knowledge would be inculcated into a captive audience — an audience which they hoped would comprise principally artisans. This we can call the 'hard' approach to the promotion of art and culture: a systematic body of knowledge and skills promulgated in a systematic way to specified audiences. It was hoped and intended, meanwhile, that this 'hard' approach to the promotion of art would, somehow, react back upon the general population, raising the general levels of taste.

We have already noted that, partly as a consequence of the form of organization and management that the schools adopted and, after 1852, as a consequence of the policies introduced by Henry Cole, the Government art school system moved away from its initial narrow approach towards a broader-based provision of art education and teaching at several levels. Despite this broadening of the approach to education, however, the promotion of art and knowledge about art via direct schooling can continue to be understood as a 'hard' form of State intervention.

Henry Cole's achievement at the Department of Science and Art was to develop a separate and complementary approach to the promotion of art — one that can be called the 'soft' approach. This involves the promotion of art and culture by example rather than by pedagogy; by entertainment rather than by disciplined schooling; and by subtlety and encouragement, rather than explicit and direct assertion. This was achieved through his development of the South Kensington Museum and through his general promotion of, and arguments for, museums.

While Cole retained the Government's particular commitment to the elevation of the taste and art-knowledge of the working classes, it is noteworthy that the 'soft' approach indicated a complementary movement towards a commitment to an art provision for the population as a whole — towards State intervention in art as a provision for the general population.

An extract from a speech Cole delivered in November 1857 illustrates well the character of the 'soft' approach:

> The working man comes to this Museum from his one or two dimly lighted cheerless dwelling-rooms, in his fustian jacket, with his shirt collar a little trimmed up, accompanied by his threes, and fours, and fives of little fustian jackets, a wife, in her best bonnet, and a baby of course under her shawl. The looks of surprise and pleasure of the whole party when they first observe the brilliant lighting inside the Museum show what a new, acceptable, and wholesome excitement this evening entertainment affords to all of them. Perhaps the evening opening of Public Museums may furnish a powerful antidote to the gin palace.[56]

'Surprise', 'pleasure' and 'entertainment' are three key words in this extract; people were to be encouraged to imbibe and absorb art and culture in pleasurable surroundings, and within family groupings.

Also, however, and in relation to our discussion of State intervention in art and culture as a moral force, note words and phrases such as 'wholesome excitement', 'acceptable', and 'a powerful antidote to the gin palace'. The promotion of art was not seen as simply an end in itself: it was seen as an alternative to those forms of social activity and intercourse seen as undesirable. However, an important aspect of Cole's understanding of the 'soft' approach to State promotion of art was that he did not see such provision strictly in relation to measures for the direct control and repression of those activities considered undesirable. James Silk Buckingham, through his Select Committee on the 'vice of intoxication among the labouring classes' had argued for the provision of museums in relation to the direct control of drink: Henry Cole, in contrast, proposed 'to go into competition with Gin Palaces'.[57] At the South Kensington Museum wine, beer and spirits were served, and he believed the provision of alcoholic, as well as other refreshments, to be an important part of making the museum an attractive place to visit. Cole was an advocate for 'anything that will bring people together and give them innocent amusement, for when a multitude is drawn together, the company exercise a restraining influence, and men are less likely to appear drunk.'[58]

Cole was an advocate, on this principle, for Working Mens' Clubs 'managed by a committee of working men', for, in such places, where drink is sold, 'the restraining principle that I refer to acts beneficially'. Closest to his heart, however, and 'in competition with the Gin Palace' was the South Kensington Museum — the model for a form of artistic and social centre that he believed should be copied throughout the country:

> During my connection with it, [it] has been visited by over thirteen millions of people, but during that time I have only heard of one person having been turned out for drunkenness, though wine, spirits and beer are sold there. Now here is the fact that if people are got to visit these places where they get amusement and can do pretty much as they like, there is no drunkenness at all. Every town should have its South Kensington Museum.[59]

Cole's vision of a society within which such museums would take their place was an essentially optimistic one. He believed in the possibility of a society with less pauperism, a more responsible capitalist class, and public provision of amenities and facilities. In a speech delivered to students at Nottingham School of Art, three months before his retirement, he declared:

> I even believe that the science of political economy will discover the means how to give the agricultural labourer as good a house over his head, as comfortable a bed to lie upon, plenty of as good food to eat, and such proper covering for his body, as a cart-horse worth fifty pounds now gets.
>
> I don't believe such conservative progress is visionary, and with it Schools of Science and Art will multiply. Every centre of

10,000 people will have its museum, as England had its Churches for far and wide in the 13th century. The Churches in the 13th century were the receptacles of all kinds of art work. Every Church had its paintings, sculpture, metal decoration, architecture, music, and was in fact a museum.[60]

Cole saw the development of public provision in education, museums and libraries as a response to a growing democratic feeling among the population, particularly among the populations of the major industrial cities. Thus in a speech delivered in 1857 he argued that:

It is proved that as a people become intelligent and free, so are they likely to demand Public Education and to be willing to pay for it. Manchester, the scene of the Peterloo riots in 1819, where the democratic feeling has certainly not diminished, although it is perceptibly tempered by increased intelligence, is among the first places in this country to agree to a local rate to support a Free Library, and this willingness to tax themselves for education is remarkable chiefly on the part of largely populated manufacturing centres, where the politics are what may be termed ultra liberal. Salford, Bolton, Sheffield, Norwich, Kidderminster, Preston, all tax themselves for Free Libraries.[61]

Henry Cole is probably the single most important individual to have occupied a powerful position within any British institution established or financed by Government for the promotion, patronage or support of the visual arts. Cole combined a clear view of what he wanted with a critical analysis and understanding of the society within which he was working and a precise understanding of what Government could do, and how it should do it. He had a decisive influence on the shaping and development of State involvement in the visual arts in Britain, an achievement that is best summarized in his own words in another extract from the speech delivered at Nottingham School of Art three months before his retirement:

Since the year 1852 I have witnessed the conversion of twenty limp Schools of Design into one hundred and twenty flourishing Schools of Art in all parts of the United Kingdom, and other schools like them, in the Colonies and the United States. Five hundred night classes for drawing have been established for artisans. One hundred and eighty thousand boys and girls are now learning elementary drawing. Twelve hundred and fifty Schools and Classes for Science instruction have spontaneously sprung up. The South Kensington Museum has been securely founded as a National Centre for consulting the best works of Science and Art, as a Storehouse for circulating objects of Science and Art

throughout the Kingdom. Whilst this Museum itself has been visited by more than twelve millions of visitors, it has circulated objects to one hundred and ninety-five localities holding exhibitions, to which more than four millions of local visitors have contributed about ninety-three thousand pounds. [62]

# Art, knowledge, and professionalization — Poynter's Preface

It is significant that in the speech quoted at the end of the last chapter Henry Cole referred to the conversion of 'twenty limp Schools of *Design*' into 'one hundred and twenty flourishing Schools of *Art*'. Cole had presided over a period when the fine art emphasis of the schools had become increasingly dominant. It is appropriate in this chapter, therefore, to step back from the historical detail of the development of particular institutions and organizations to examine something of the philosophies and assumptions underlying the development of fine art as a profession and practice. We shall do this through the examination of one short piece of writing by E. J. Poynter, a man who, from 1875, was Director of the Art Division of the Department of Science and Art, and who, at various times in his life, was a painter, Slade Professor of Art, Principal of the National Art Training School (now Royal College of Art), Director of the National Gallery and President of the Royal Academy.

In the 1880s E. J. Poynter was editor of a series of *Illustrated Textbooks of Art Education*, a series of general textbooks giving basic accounts of various schools of art and architecture. Poynter himself wrote *Classic and Italian* and it is at the general Preface to the series as printed in that volume that we are to look. The Preface is dated 1880, the volume *Classic and Italian*, meanwhile, was published in 1885.

In examining the Preface we are not treating it as a great or significant piece of philosophy or aesthetics. We are seeking simply to examine something of the social relations of art at that time, as expressed through the writing of a man who, during his life, occupied most of the most important and influential positions in the main institutions concerned with the visual arts.

## The Preface

The theme of Poynter's Preface is the importance of, and need for, a sound knowledge of art history. A sound knowledge of art history, Poynter argues, is the only basis for the development of taste and discrimination. However, the opening to the Preface is pessimistic, for 'that class of the public which

possesses the means of encouraging art' lacks, in Poynter's opinion, the knowledge necessary for the formation of taste:

> It is no doubt the business of artists to educate the public in matters of art by raising the standard of taste through their own productions, whether these take the form of architecture, sculpture, painting, or the industrial arts. And it is equally without doubt that public opinion reacts, and not always too favourably, upon art, by creating a demand which can but rarely be up to the required level of taste and critical knowledge; and this must be the case so long as that class of the public which possesses the means of encouraging art remains for the most part, in a Dogberry-like belief that the appreciation of what is excellent in architecture, painting, or sculpture 'comes by nature'.

This 'problem' was particularly urgent in the 1880s, because:

> Whereas the patronage of the arts was formerly confined to a small class, in the present day we have entered upon a new and different phase.

In other words, patronage exercised almost exclusively by a small aristocratic circle had given way or expanded to include a wider middle class public:

> An interest in art . . . has sprung up . . . which is increasing far beyond the circle of the few highly cultivated persons who at one time constituted the amateur classes.

Poynter viewed this development pessimistically, for he felt it possible that the new interest in art among an expanded public was no more than a fashion, and a 'fashion' is distinguished by:

> the opportunity it affords for quackery and advertisement among some so-called 'art' companies and tradesmen.

It was in the late nineteenth century that private, commercially-run galleries began to develop in London. The pattern of art marketing via direct transactions and commissions between artist and patron, and via major mixed exhibitions controlled and organized by artists in academies and societies, was being supplemented by a new form of commercial marketing directed toward the new wealthy classes. This was removing the control of taste, art and culture from the small circle of influential people who, particularly in the eighteenth century, had been as much in control of taste and art as they were in control of all other aspects of social, political and economic life.[63]

Poynter contrasted the situation in art adversely with that in literature. Most boys in public schools, Poynter suggested, are taught a knowledge of Greek and Latin literature, and the study of this is the foundation of:

... a discriminative taste for the higher forms of literature, to the
beauties of which his mind may be opened through the study of
the best classic models.

Poynter went on to summarize the sorts of things boys would learn of classical
literature 'to form their taste', adding that, in contrast;

It is doubtful whether the large majority of boys would not be
puzzled by any illusion to the names of Phidias or Michelangelo.

Thus, while the foundations for a correct literary taste existed, the same basis
was lacking in the visual arts.

## The supremacy of intellectual knowledge

At the time when Poynter wrote, Government organized art education had
been developing and expanding for forty years, not only within the art
schools, but within general elementary education. Poynter was not unaware of
this:

A smattering of drawing . . . has been at most schools within the
reach of those boys whose natural instinct has led them with more
or less insistence in that direction.

He commented approvingly that drawing is becoming 'every year more
general and is improving in quality'. However, and this is the crux of the
argument:

. . . Unless under very able direction, this tends but little towards
the cultivation of taste.

Poynter was placing an intellectual knowledge of art history far above the
practice of art as the basis for the formation of taste; in fact:

Technical knowledge . . . and even great skill and originality as
an artist, may exist in an individual in company with the most
absolute indifference to any form of art that lies beyond his range
of ideas; and there are many cultivated men whose opinion on a
work of art is much to be preferred to that of many artists.

The only basis for a correct taste is, in fact;

an acquaintance with the great works of art that are standards of
style; such works, that is to say, as have received the sanction of
cultivated men of all times.

41

Poynter was invoking a tradition of judgements, assumptions, beliefs and norms built up from the Italian Renaissance to the late eighteenth century; 'the sanction of cultivated men of all times' is central to his argument — such men, of course, tending to be western European, upper class, and post-medieval (though with reference also to classical Greece and Rome). The tradition Poynter was invoking was a specifically defined one, and the product of particular social relations and historical changes. His problem was that the changing nature of society in late nineteenth century Britain was threatening the conditions under which that tradition had developed and been maintained. There was a danger that taste and culture would be taken over by a new class of people with a different understanding of the world and a different approach to life; hence with different demands of and understandings of art.

Poynter's central concern was with the male middle and upper classes. This was the influential group in matters of taste, and it was in particular these groups who, in his view, required a better education in the knowledge of art:

> The least that the future possessor of a fine house or a picture gallery can get from such studies will be an insight into his ignorance concerning things which surround him, and meet his eyes at every turn; and if his interest in them carry him but little further than the acquisition of a certain number of names and dates by heart, the mere fact that he has been taught these may be an indication to him of their importance.

Poynter, therefore, as a professional artist invoking and laying stress on the intellectual tradition and history of fine art, was hoping that this very minimal spreading of art historical knowledge would at least lead those with influence to recognize that there was a tradition, culture and profession of art that deserved respect, which had its own integrity and its own distinctive standards. He was making a claim for the importance and professional expertise of his own profession, and the tradition to which that profession had access. He was also asserting the integrity of the art tradition and profession in the face of what he saw as the commercialism and market orientation of his own society. Thus he argued:

> It seems hardly doubtful, then, that it would be well if our future statesmen could have it impressed on them in their youth, that some meed of the glory which Pericles had received will be their due whenever their encouragement of the fine arts tempts them to go further than the annual votes which they give with a grudging hand to the three museums of London . . . And it will be well also if our future Mummiuses shall have been taught as schoolboys that works of beauty and skill have a value in themselves independent of their market price.

There are, therefore, two main strands in Poynter's argument. First, he was

asserting the importance of art as an intellectual tradition; second, he was arguing against the threat to this tradition that he saw in the market orientation and values of late nineteenth century Britain.

These arguments are fundamental to the way State involvement in the visual arts has developed in Britain. We looked earlier at the arguments made by Beresford Hope[64] about the need for a 'central regulating influence' for art, this 'central regulating influence' to comprise artists and lovers of art; similarly, we shall be looking in later chapters at the arguments made in the 1940s for the establishing of the Arts Council of Great Britain. Underpinning all these arguments is a common distrust of what happens to the visual arts in the market place and in the hands of new social classes. Throughout, the importance and expertise of the 'professional' (art historian, art expert, artist, art lover) is asserted against the taste and habits of the general population. Art, it is suggested, is too important to be left in the hands of Government, business, or the population at large. Aesthetic judgements, it is argued, require expert knowledge, advice and guidance.

The social and public importance of art is asserted; at the same time a need for art to be controlled, nurtured and guided apart from the general society and public is also asserted.

In its essentials, this was the argument Poynter was making in the 1880s; but such arguments also lay behind the lending of the authority and power of the State to the Academy in the 1760s; and we shall see the same arguments articulated again in the 1940s in a report called *The Visual Arts* — a seminal document in the development of the Arts Council of Great Britain.

# Art and the State, 1760 – 1880

The argument made by Poynter, and examined in the previous chapter is, as we noted, a common one, and one that has been important in the development of State intervention in the visual arts over the last two centuries. For that development of State involvement in art has in fact been a gradual process whereby various forms of State power, authority and finance have been made available in support of the definitions, assumptions and views of art held by various groups of artists, art experts and art historians. In this sense the authority of the State has been involved in supporting and promoting not ony 'professional' definitions of art, but the 'professionaliz-ation' of art. [65]

While on the one hand the increasing level of State involvement in art has promoted art as part of a public culture (public exhibitions, public museums, public education) it has also been part of the removal of the public from active involvement in the creation of that culture. For central to the development of a culture is the multiplicity of individual acts of judging, responding, feeling, using and reacting which are covered by the idea of 'aesthetic judgements'. The involvement of State power in the support of the professionalization of art and of the authority of the art professional has marginalized the role of the public in aesthetic matters, and in the active development of a public art culture.

We have noted that the State is more than the Government, Civil Service, and direct apparatus of Government administration. The State, rather, is a complex set of relations and forces including the direct political organization of Government, but also numbers of other forms of related authority and power. In the broad sense of the world 'political' the State is the political organization and expression of a society. It is the 'expression' of a society in the sense that the State is bound up with moral expressions of a society expressed in phrases like 'national interest', 'national heritage' and 'national purpose'.

The State both shapes and is defined by the organization of a society. It is not separate from the economy, the distribution of wealth and power, and the structuring of knowledge and opportunities. It is shaped by them, is the expression of them, is the organization of power and authority that maintains and reproduces them and is the form of authority and power that in turn structures and shapes them.

This is an elaborate way of saying that the State is not, as the cruder

versions of some socialist arguments have suggested, a machine or organization that can be captured, controlled or directed from the top. It is a set of relations of power and authority which is both defined by and defines individual behaviour and actions.

Thus far we have examined the establishing of the Royal Academy, the British Museum, the National Gallery, National Portrait Gellery, Victoria and Albert Museum, the National Art Training School, local schools of art and legislation for local museums of art. All these achievements were won by individual efforts, arguments and campaigns. In this sense the development and extension of State involvement in art was the direct result of the work of individuals. But the State is an authority which exists as a set of relations that is more than individuals.

It is true, for example, that a weak, ineffective or uncharismatic King or Queen could reduce the authority and reputation of the Crown, just as a strong, efficient and charismatic King or Queen could enhance and develop the authority and reputation of the Crown. Essentially, however, the authority of the Crown is separate from the authority of the particular man or woman who is King or Queen. Thus, while it is certainly true that a man known as George III founded the Royal Academy of Arts, the authority and position bestowed upon the Academy did not come from the man known as George III, but from the fact that the King founded the Academy. By accident of birth George was a member of the Royal family; on the death of his grandfather he was the oldest living male in direct line of descent from his grandfather. The authority and title of King was therefore vested in him. But that authority was neither of his creation nor, for that matter, was it his to use as and how he would.

The example of the Crown, therefore, illustrates the sense in which the relations, authorities and powers of the State are of individuals but are more than individuals. The State is the organization and expression of authority and force in a society, and while it can be used and shaped by individuals, it also shapes and is separate from those individuals.

Those, therefore, who persuaded George III to found the Royal Academy, who persuaded Parliament to establish a British Museum, a National Gallery, and a department of Government concerned with art, were doing more than simply setting up institutions that were of interest to certain sections of the population. In involving the State in these organizations they were also lending them a significance, power and status they might otherwise not have had. Equally, of course, since some of these institutions are concerned with the most prestigious aspects of art, they gave to the State (and to the nation) an added prestige and authority.

## Freedom and incorporation

A common theme in discussions of State involvement in art, both in the nineteenth and twentieth centuries, has been the dangers of State control of art. This has been seen, as we have noted, as antithetical to the conditions

necessary for a healthy and vigorous art. Thus Beresford Hope, speaking as a witness before an 1863 Inquiry into the Royal Academy, talked not only of the need for a greater regulation and systematization of Government support for art, but also of it being 'fatal if this were to lead to free opinion and free work being subordinated to bureaucratic authority'. This ambivalent attiude towards the State and State power is a characteristic of many influential groups in British society. Businessmen, industrialists, intellectuals and professional groups all tend to relate to the State as both supportive of their position and influence and also threatening to their freedoms and authority.

This ambivalence has been a common theme in discussions of Government support for the arts, and this is a theme we shall be picking up frequently in discussing the expansion of State intervention in art in the twentieth century. This ambivalence, however, is also the basis for some of the complex forms that State intervention in the arts (as well as in other areas) has taken. Thus we have noted the complex relationship of the Royal Academy to the Crown, to Parliament, and to the public. Similarly we have noted that the major national museums of art (with the exception of the Victoria and Albert Museum) have been established as Trustee museums — that is, as institutions separate from Government departments. The museums, and also the Royal Academy, conform to a model that is today known as a 'quango'.

Further, we noted that even where Government was more openly involved in art, as through the organization of art schools and the Victoria and Albert Museum under the Department of Science and Art, much of the effort was put into education by example, entertainment and amusement (the Victoria and Albert Museum) rather than education by direct pedagogy (which had been the approach originally adopted under the system of design schools in the 1840s. Moreover, while Government ran the National Art Training School in London directly, we also noted that the schools outside London were, in one sense, 'independent' of government. They did receive Government assistance in the form of grants, and the basic curriculum, examination system and teaching of the schools were all centrally controlled through inspectorate systems and the power implicit in the ability of Government to give or withhold grants. However, the schools were constitutionally separate from central Government. They were expected to raise finance locally and to be established on local initiative.

In a different way this was also the pattern with local museums of art. Legislation was passed through Parliament permitting local authorities to establish museums of art and finance them from the rates: meanwhile at central Government level a major national museum was established and developed as a model, a propaganda and example for what museums could be. Thus central Government, by example, defined what a museum could be and, via legislation, opened up the possibility of local authorities following suit. But whatever system of local and national Government museums developed it was not to be integrated into one centrally controlled system; authority was to be split between the national and local levels.

Two main characteristics of State involvement in art therefore emerge from our examination of developments in the 1760 to 1880 period: first, a tendency

to adopt a 'quango' model; and second, a tendency where Government is directly involved in art at a national level, to relate this direct involvement to forms of more indirect control at a local level. Both these models are central to the way State involvement in art was to develop in the twentieth century.

The 'quango' model is particularly important in relation to the ambivalent attitude of professional and intellectual groups to State power. For a quango is not only characterized by being constitutionally separate from the direct machinery of Government; it is also characterized by its use of semi-official and unofficial professional advisors, volunteers and members. Thus a quango, while carrying the financial and moral authority of the State, is also separate from the direct political control of Government, and incorporates within itself, either in an advisory or managerial role, members of that very group of people who feel uneasy about the direct political involvement of Government.

The quango thus solves a central problem of State power in Britain. It is a form of response by the State to pressures, arguments and forms of authority outside Government. Sections of influential groups, classes and organizations are incorporated into the machinery of State power, while yet at the same time being distinct from Government.

The quango model of State organization has two important consequences: first, by incorporating influential groups into the State organization, any opposition, dissidence and argument is restricted. Second, large areas of public policy are removed from direct involvement with Government, Parliament and the electorate. These areas are, in a sense, privatized, through being handed over to professional organizations that are not part of the public machinery of political decision making.

While the danger of Government control is a common theme in discussions of art and the State, one often has the feeling that underlying the explicit discussion of the 'dangers' of Government involvement is a second, implicit, theme: the 'danger' of democracy in the arts. The quango model neatly avoids both these dangers; direct Government control is avoided, while any threat of democratic control that might be implicit in the idea of political control is submerged within a system of professional advisors, volunteers, trustees, experts and nominees.

In the eighteenth and nineteenth centuries both the quango model of State authority, and that involving a complex series of relationships between national Government and local authorities and groups, were firmly established. In the following chapters we shall explore the ways in which these forms of State involvement in art were developed in the twentieth century.

# The Arts Council of Great Britain

On the 9 August 1946 a Charter of Incorporation was granted by George VI to the Arts Council of Great Britain. Thus was established on a permanent basis, and in a modified form, the temporary wartime institution known as the Council for the Encouragement of Music and the Arts (CEMA).

In its origins CEMA was a private (non-State) organization. The 'inspiration and, indeed, the catalyst'[66] was Dr Thomas Jones, Secretary of the Pilgrim Trust, and it was the Pilgrim Trust who established CEMA with an initial grant of £25,000.

Jones had been involved, in the 1930s, in 'Art for the People', a scheme devised by W. E. Williams and carried out by the British Institute of Adult Education, whereby travelling exhibitions toured the country. Among the most important aspects of CEMA's work in the visual arts was to be first, the funding (and expansion) of the British Institute of Adult Education's scheme, and second, the development of its own scheme for travelling exhibitions.

While the initial funding of CEMA was private, the Board of Education came to match the Trust's funding with a further £25,000 after four months, Government funding gradually increasing in importance until March 1942, when the Pilgrim Trust ceased contributing funds altogether, all further finance coming from Government.

While at one level, therefore, the involvement of Government in art through CEMA can be understood in financial terms as a gradual shift from 'privateness' to 'publicness', at other levels the picture is more complex. In fact the development of CEMA and of CEMA's role within the State is reminiscent of the development of the Great Exhibition of 1851, where the same combination of private support, official backing and individual initiatives was involved.

Thus, while CEMA's initial funding was private, it received the personal support of Government ministers (for example in the backing given by Lord Macmillan, Minister of Information, and Lord De La Warr, President of the Board of Trade). Further (and of crucial importance), Lord Macmillan was also Chairman of the Pilgrim Trust. Thus in a private capacity a Government minister was involved in a scheme subsequently to be entirely financed by Government.

Macmillan had been created a life peer in 1930 (Baron of Aberfeldy). He

had a distinguished career as chairman and member of many boards, commissions and trusts — in fact, the sort of career that can be described as a 'distinguished career of *public* service'. He is illustrative, therefore, of an important factor in the workings of the British State — a 'private' but 'public' figure; a man who in one sense can be described as a 'career chairman'. As such he illustrates the sense in which many organs of public life which are apparently distinct in function and purpose actually overlap through the membership of boards of management, councils and trusts.

As a life peer, of course, Macmillan was also a non-elected member of the legislature, and thus occupied an official position within the machinery of Government. The House of Lords is a far from redundant institution. It is not only a forum for debate; it constitutes and signifies the continuing recognition of the power and involvement of the British aristocracy (both traditional and newly created) in public life. This involvement is expressed not only through the House of Lords itself, and the inclusion of non-elected peers in Government, but also through the membership of peers in numerous official, semi-official and private bodies. Just as the patronage of the Royal family lends authority and prestige to institutions, so, in a lesser sense, the patronage of a peer lends a similar authority and prestige.

Lord Macmillan's involvement, therefore, in both Government and the Pilgrim Trust illustrates an important facet of the workings of the British State. He is also illustrative of an amateurism that is built into the system. We discussed earlier how the quango model of exercising power often involves an incorporation of elements of the professional classes, interest groups and organizations into the workings of the State. We should also note that such groups are usually incorporated into organizations at a level subordinate to the main body of management. This latter often comprises 'public' figures who have a career in 'public life' and committee work, without necessarily having any specialist knowledge of the subject matter of the particular organization. In this sense they are amateurs rather than professionals.

In some cases, of course, individuals can be described as both 'public figures' in the sense described above, and 'professionals' in the sense of having specialist knowledge and a career in a particular area. For instance, one of the original four members of the Council of CEMA was Sir Kenneth Clark, Director of the National Gallery, Director of the Film Division of the Ministry of Information and Surveyor of the King's Pictures.

In the early part of the Second World War CEMA distributed its resources in the form of grants to other organizations. Within a year, however, CEMA began acting on its own initiative — that is, it began to organize and control the provision of the arts directly. It maintained mobile companies and groups in music and drama, taking concerts and performances to all manner of town, village and venue.

In the visual arts CEMA began by funding the British Institute of Adult Education's *Art for the People* scheme, enabling BIAE to increase its annual number of toured exhibitions from a pre-war four or five to eighteen in 1941, thirty in 1942, and forty-two by 1944.[67] Meanwhile in 1942 CEMA began to mount its own exhibitions, starting with nine in 1942, and building up to

thirty-seven by 1944. In total, in 1944, the BIAE and CEMA together exhibited in 208 art galleries and in 522 other places.[68]

CEMA, however, was concerned with all the arts, not simply with the visual arts. In fact, between 1939 and 1944 only about one-eighth of its budget was to be spent on the visual arts.

Another wartime development is perhaps more interesting, although it was only to contribute marginally to post-war developments and Arts Council thinking. This was the establishing of the War Artists' Committee in 1939. This Committee, set up under the aegis of the Ministry of Information (and following a precedent set in the First World War) administered an annual budget of about £14,000 on employing and commissioning artists and buying works of art. The emphasis was on artists recording places and events. Meanwhile the Admiralty, War Office, Air Ministry and Ministry of Transport also had artists assigned to their staffs, these artists being paid out of the allocations of the various ministries or departments.

Unlike CEMA, these various schemes were abandoned after the war; their success, however, contributed to later thinking on bursaries, awards and public commissions for artists.

## CEMA and the Arts Council

CEMA was an interesting development in State involvement in art for, while it conformed to the quango model (by the end of the war its Council was appointed by the Minister for Education, but it was separate from Government) it departed from the usual practice that existed both before and after the Second World War in the extent of its central control over, and management of, cultural policy and administration. It was a wartime emergency measure established to help maintain national morale; it therefore did not have the time or luxury to concentrate on prestige shows in major metropolitan centres for an existing and established audience. It could not wait for local authorities or groups to establish exhibition venues, or ask for assistance. Its policy had to be much more vigorously outgoing.

It was the pressures of war that both produced CEMA and led to this vigorous national policy. The establishment and success of CEMA laid the foundations for the Arts Council of Great Britain. The Arts Council, however, was to develop in peacetime without the urgency of war to compel it toward some of the radical measures undertaken by CEMA in the promotion and distribution of the arts. CEMA, through the central promotion and distribution of art, had come near to breaking the convention whereby the State was involved with and supportive of art without appearing to control or organize art.

The establishment of the Arts Council was to signal the re-establishment of the ideologies of professionalism and expertise in art, in contradiction to ideas of planning and control. This process is neatly illustrated in a report called *The Visual Arts*, produced by The Arts Enquiry and sponsored by the Dartington Hall Trustees.[69]

The Arts Enquiry was established in autumn 1941, and staffed by the Arts Department at Dartington Hall. It was based in London at offices provided by Political and Economic Planning, and the Nuffield College Social Reconstruction Survey was associated with its work. The Arts Enquiry was coordinated by a main committee[70] comprising a group of public figures involved in the arts. Specialist subcommittees were established to produce the various reports, *The Visual Arts* being produced by 'a group of fourteen experts, among them artists, designers, gallery directors, art critics, art school principals, teachers of art and secretaries of art societies'.[71] Peculiarly, as many of these individuals 'hold official positions', the report was produced anonymously.

The report was a substantial work (176 pages plus index). A first complete draft was produced by the committee of fourteen and this was then taken to a conference of seventy specialists in the visual arts. A new draft incorporating the comments of these specialists was then circulated to the specialists from the first conference and to other 'experts'. In all, over two hundred people were involved in the compilation of the report.

While the report was published in 1946, its proposals and recommendations were first formulated in 1944. This two-year gap must be understood in relation to the consultative process described above — that is, the report's text and argument were in discussion among a privileged group well before publication. While, therefore, the Council for Industrial Design and the Arts Council were announced by Government *before* the publication of *The Visual Arts*, the Enquiry's arguments and recommendations for the establishing of a Design Council and an Arts Council were in circulation well before the Government's announcements.

Central to the Enquiry's argument is a critique of the consequences and effects of an uninformed popular taste and patronage of art. Thus, while critical of aspects of the relations between aristocratic eighteenth century patrons and their artists, they noted approvingly that 'the taste and knowledge of eighteenth-century patrons made possible the rise of the British School of Painting'. In the nineteenth century, they noted, 'the aristocratic tradition of connoisseurship waned, although buyers increased in numbers'.[72] The majority of the new patrons of the nineteenth century:

> ... had no tradition and relied on untrained likes and dislikes, without either the discipline of recognised standards or a sure knowledge to guide their taste. They paid increasingly huge prices in competition for the work of the most popular artists.[73]

While this led, the Arts Enquiry suggested, to an increase in the number of artists, the increase in demand 'was more than the short-lived and limited tradition of English painting and sculpture could withstand.'

The argument put forward by the Arts Enquiry is very close to that we saw presented by E. J. Poynter in 1880: a new wealthy class had developed, but this class lacked the traditions and knowledge of its predecessors, and, as a result, art was suffering. New money was corrupting the traditions of art.

51

The Arts Enquiry's argument, however, also contained an interesting mix of appeals to both democratic ideals and more exclusive ideas. Thus the Enquiry commented that in the nineteenth century: 'A great new public was growing up that might have shaped the traditions of the past to satisfy the needs of a more democratic structure of society'[70] and that, in the twentieth century, the problem was to extend 'the number of discerning buyers . . . throughout the country, and so to build up a tradition of patronage fitted to the democratic organisation of society.'[75]

The Arts Enquiry, like E. J. Poynter, wanted a greater public involvement in and patronage of art, but was unhappy with the forms and patterns that had emerged. The word 'democratic' in the two quotations above is interesting, for while it is used to appeal to a notion of 'popular', the actual word 'popular' is consistently used in the report in a derogatory sense, as is the word 'fashionable'. These concepts, as applied to art and artists, are set against concepts such as 'serious' and 'original' — the latter being linked to the traditions of connoisseurship and discrimination built up in the eighteenth century.

This ambivalence between a positive use of an idea of democracy and a negative use of the idea of popular is expressed in comments the Arts Enquiry made on the Royal Academy. The Academy's influence, the Enquiry commented, had declined during the previous forty years. This decline, they argued, was in part due to the Academy's interpretation of its functions. These functions had recently been described by the Secretary to the Academy:

'Among a great variety of efforts, some uncertain in their aim, others aiming at surprise, it must look for real achievement that will be comprehensible and enjoyable to the ordinary visitor who seeks a ready means of cultivating a personal taste in contemporary art.'[76]

This approach was obviously too 'populist' for the Arts Enquiry. The Academy, moreover, as the most powerful art institution in the nineteenth century, symbolized for the Arts Enquiry all that was wrong with art. The Academy had dominated, or responded to, popular taste; provincial museums and art gallery collections had been established as if permanent academies; serious and difficult art had been neglected.

The Arts Enquiry's 'solution' to the problems as it understood them was the establishing of an Arts Council. The Arts Council they proposed was essentially that established under the Charter of 1946, although with some minor differences. Thus they saw the Arts Council as incorporating the functions of the Standing Commission for the National Museums and Art Galleries, these functions to be extended to include the foundation of new collections and institutions, and greater power in promoting cooperation between national and provincial galleries.

This recommendation aside, however, the organization outlined in the 1946 Charter was essentially that suggested in *The Visual Arts* — this in turn

being a modified form of the organization already in existence under the title of the Council for the Encouragement of Music and the Arts.

Essentially the Arts Enquiry was arguing that the functions of eighteenth century aristocratic patronage should be exercised in the twentieth century by a 'public' authority exercising and distributing the State's patronage. In this sense they combined an anti-populism with what they may have understood to be a form of 'patronage fitted to the democratic organization of society'.

## The Arts Council of Great Britain

The 1946 Charter of Incorporation of the Arts Council defined the organization as being:

> For the purpose of developing a greater knowledge, understanding and practice of the fine arts exclusively, and in particular to increase the accessibility of the fine arts to the public throughout Our Realm, to improve the standard of execution of the fine arts and to advise and co-operate with Our Government Departments, local authorities and other bodies on any matters concerned directly or indirectly with those objects.

This Chapter was subsequently amended in 1964 and 1965, and a new Charter issued by Queen Elizabeth II in February 1967. The changes that concern us here were the redefinitions of the 'objects' of the Council, which were both altered and simplified:

> (a) to develop and improve the knowledge, understanding and practice of the arts;
> (b) to increase the accessibility of the arts to the public throughout Great Britain; and
> (c) to advise and co-operate with Departments of Our Government, local authorities and other bodies on any matters concerned whether directly or indirectly with the foregoing objects.

In the 1967 Charter the phrase 'the fine arts exclusively' was dropped in favour of simply 'the arts', and the 1946 Charter's 'to improve the standard of execution of the fine arts' was omitted altogether, although its meaning was covered by the addition of the verb 'improve' to the existing verb 'develop', as used in the first part of the definition of objects in the 1946 Charter.

The Arts Council is defined in the 1967 Charter as being a body of not more than twenty people, including a Chairman and Vice-Chairman. The members of the Council are appointed by the Secretary of State for Education and Science, in consultation with the Secretaries of State for Scotland and Wales. The Chairman is appointed by the same Secretaries of State and the Vice-Chairman is appointed by the Council with the approval of the Secretary of State for Education and Science.

The Council is empowered to establish committees and panels to advise it as it sees fit, and is empowered to appoint to them persons who are not members of the Council, as long as the chairman of a committee or panel is a member of Council.

All members of Council, committees and panels serve unpaid, though expenses can be reimbursed.

Members of Council are appointed for a maximum period of five years, after which one year must elapse before reappointment, unless the Council member is the Chairman or Vice-Chairman of Council (or of the Scottish or Welsh Arts Councils) or is chairman of a panel, in which case he or she can be reappointed without a break.

The Scottish and Welsh Arts Councils referred to above were formally named under the 1967 Charter. Constitutionally they are committees of the Arts Council of Great Britain, their Chairmen being members of the Arts Council of Great Britain.

The principal executive officer of the Council is a Secretary General, who is appointed by the Council on the approval of the Secretary of State for Education and Science. The Council is empowered to appoint further officers and staff as it sees fit.

The Council is required under its Charter to keep proper accounts and other records, and to prepare after each financial year a statement of accounts as directed by the Secretary of State for Education and Science with the approval of the Lord Commissioners of the Treasury. The Council is also required by the Charter to make a report to the Secretary of State for Education and Science, after each financial year, on how they have performed their functions.

In summary, therefore, the Arts Council is established under the authority of the Crown, and its members are appointed by the relevant Secretaries of State, and, within the terms laid down by the Charter, the Council is accountable to the Secretary of State for Education and Science. Most of its finance is received as a grant from Parliament. The importance, however, of the Council existing under the authority of the Crown is that, while it is accountable to the Secretary of State for Education and Science, both the Council *and* the Secretary of State are bound by the Charter as established by the Crown.

The essence of the quango model as established for the Arts Council through its Charter in 1946 was summarized in the Council's first annual report: 'Henceforward, the Council has a corporate existence, with official status, yet increased autonomy.'

## John Maynard Keynes

Lord Keynes became Chairman of CEMA in 1942, subsequently and briefly becoming first Chairman of the Arts Council of Great Britain until his death on Easter Sunday 1946. In 1945 Keynes made a broadcast on the BBC Home Service on *The Arts Council: its Policy and Hopes.*[77] The broadcast summarized something of the assumptions then current concerning both the

Arts Council and the arts. Talking of CEMA and the Arts Council Keynes said: 'I do not believe it is yet realised what an important thing has happened. State patronage of the arts has crept in. It has happened in a very English, informal, unostentatious way — half baked if you like.'

State patronage of the *visual* arts was not, of course, a new thing — nor, for that matter, was State involvement in literature via the provision of libraries. From the sixteenth century, moreover, the State had been involved in the *control* of the performing arts through the licensing of theatres, while in the twentieth century (and prior to the founding of the Arts Council) the BBC had involved both State promotion and control of broadcasting. The factual basis for Keynes' comment was that a regular commitment to State *funding* of the *performing* arts was a new and important development embodied in the Arts Council. In fact the assumptions Keynes makes in describing the arrival of the Arts Council as the arrival of State patronage of the arts illustrates an important feature of developments in State involvement in culture in the twentieth century: namely that these have been much more concerned with the performing arts than with the visual or literary arts.

What Keynes' statement also illustrates, however, is something of the amateurism built into the Arts Council, which we referred to earlier as a feature of the quango model. Thus Keynes refers to State patronage as having '*crept* in', — crept in in an 'English', 'informal' and 'unostentatious' way. Such phrasing has echoes of a gentlemanly or aristocratic style. By gentlemen's agreement Government was to support the arts, but support was to be channelled according to a style more akin to a gentleman's club, than to a Government ministry.

The non-Governmental character of the new development was emphasized again when Keynes said:

> But we do not intend to socialise this side of social endeavour. Whatever views may be held by the lately warring parties, whom you have been hearing every evening at this hour, about socialising industry, everyone, I fancy, recognises that the work of the artist in all its aspects is, of its nature, individual and free, undisciplined, unregimented, uncontrolled. The artist walks where the breath of the spirit blows him. He cannot be told his direction; he does not know it himself.

It was these assumptions about the nature of the way an artist works, therefore, that were held up as supportive of the form of 'half-baked' State intervention that was being developed.

In Keynes' view the Arts Council was to be a body that supported a culture, rather than planned or directed it. Thus 'the task of an official body is not to teach or to censor, but to give courage, confidence and opportunity.' He added; 'Do not think of the Arts Council as a schoolmaster. Your enjoyment will be our first aim.' However, later references to the BBC, including 'I believe that the work of the BBC and the Arts Council can react backwards and forwards on one another to the great advantage of both', illustrate something of the paternalistic style that was to be built into the Arts Council.

# National and Regional Policy

The Arts Council of Great Britain was established as a national body. A crucial element in its Charter is the statement that it exists 'to increase the accessibility of the Arts to the public throughout Great Britain'. The implementation of this object required planning and thought and a specific form of intervention in the cultural provision of the country as a whole.

However, the Arts Council, in its early years, built various assumptions into its work and subsidy which rendered the implementation of the second object of its Charter highly problematic. The major decision was that the Council should 'respond' to the initiatives of others, rather than promote or organize the arts directly on its own initiatives. This policy of response was therefore established in antithesis to the possibility of planning.

Second, the Council took, as the most important element in its Charter, the phrase, 'to improve the standard of execution of the fine arts'. Pursuit of 'standards' and 'excellence' became the main concern of the Council, and this pursuit was set in antithesis to the possibility of a clear national policy or the spreading of the arts nationally. The options have been summarized in terms of the alternatives of 'raising' or 'spreading', and the line adopted by the Council was expressed by the phrase, 'few but roses'.

This attitude is interesting not only for the effects it had on the formation and development of the Arts Council as a 'national' organization, but for its implicit aesthetic assumptions and associated policies. Both these can best be explored through an examination of the Arts Council's regional policies over a thirty-year period. We shall, therefore, examine the Arts Council and regional developments in terms of s history broken into three ten-year periods: 1946–56, 1956–66 and 1966–76; and the five-year period 1976–81.

*Retraction and centralization: 1946–56*
During the Second World War CEMA had worked through a series of regional offices headed by Directors. These offices were based in Newcastle-upon-Tyne, Leeds, Nottingham, Cambridge, Bristol, Birmingham and Manchester. Additionally officers dealing with Kent, Middlesex, Surrey, Sussex and Berkshire, Buckinghamshire, Dorset, Hampshire, Isle of Wight and Oxfordshire were based in the Arts Council headquarters in London. Cardiff and Edinburgh had further offices with Directors. The staff of the regional offices handled promotional work and the effecting of CEMA's nationally determined policy. Additionally, 'they acted as a kind of citizen's advice bureau on matters concerning the arts, and in both capacities earned a substantial amount of public goodwill.'[78] However, not only were these regional officers and their directors constitutionally subordinate to CEMA but regional policy also had no formal place within the decision making and management structure. Thus, as Eric White points out in writing about the beginnings of the Arts Council:

> The Chairmen of the panels for drama, music, visual arts, and
> poetry were all members of the Council, at whose meetings they
> could argue and defend their panels' views; but there was no

formal panel or committee for regional work, and it was only by chance that a Council member might happen to live outside London or be familiar with some part of the country and so feel able to pronounce on a particular regional issue.[79]

The 1946 Arts Enquiry's report on *The Visual Arts* had recommended that;

'In the provinces there should be regional offices on the lines of the present CEMA offices, which should be in charge of regional directors. In each office there should be at least one officer for each branch of the Council's work, and sufficient staff to originate regional activity.'[80]

The important point in this recommendation was the inclusion of the verb 'to originate', in relation to regional activity. The Enquiry was proposing a greater degree of formal power for the regional offices.

However, such a proposal, which had implicit within it the idea of a national service for supporting the arts, ran against the thinking developing within the Arts Council on matters of standards, excellence, and a response to the initiatives of others. A paragraph in the Arts Council's report for 1955–56, referring to the performing arts, reflects this thinking in saying;

'Covent Garden, Sadler's Wells and the Old Vic, then, as three national institutions endeavouring to provide exemplary performance in the metropolis are a primary responsibility of the Arts Council.'[81]

The key phrases here are 'national institutions', 'exemplary performances' and 'primary responsibility'. 'National' was being equated with 'London' and a metropolitan view of culture, and the maintenance of standards in terms of 'exemplary performances' was seen as their 'primary responsibility' on the grounds that, through an unspecified process, such exemplary performances would, somehow, react back upon and affect the rest of the country. Thus in 1953 it was argued in an Arts Council annual report that 'Diffusion can reach the stage where it becomes dilution, . . . The diffusion of quality depends, above all, upon the existence in London and in several provincial centres of power-houses of the arts'.[82]

Whereas CEMA had sent performing companies and exhibitions to all parts of the country and all manner of venue, the Arts Council, in the early and mid 'fifties, came close to rejecting the possibility of there being a non-metropolitan demand for art. In their eleventh annual report they attributed CEMA's success to CEMA having had a 'captive' audience, while in 1953 it was argued that;

Participation in a village choir is, of course, a different experience from attending a symphony concert once a week. But it is a salutary one, and the nearest that the average villager can get to

'live' music. He can no more get the other thing than his urban kinsman can expect to be provided with bird-watching facilities. [83]

It was in relation to and as part of this move towards a metropolitan view of culture, with a concentration on the idea of 'raising standards', 'exemplary provision', and so forth, that the Council came to view the maintenance of its regional offices as unnecessary. They had no policy towards the country as a whole; they were concentrating exclusively on the idea of art as a professional and non-participatory activity. In the performing arts most of CEMA's direct provision and promotion was disbanded (this being part of the policy of response rather than initiation) and, since that which was responded to and considered to be excellent tended to be London based, the regional offices in England were redundant. Three were closed in 1952, one in 1953 and the remainder by 1956.

By the end of the first decade of its operations, therefore, the Arts Council had become a heavily centralized body. It had reasserted a tradition of art expressed through exemplary standards as recognized by the cultivated few, in opposition to the diversity of practices, activities and audiences which the success of CEMA had at least hinted at.

With an extraordinary confidence it was asserted in the Arts Council's 1956 report that 'These changes do not represent, as some critics have declared, any doctrine of 'centralisation' . . . the closure of the regional offices implies no change in the direction of Council policy.' [84]

This assertion was at least true in the sense that it was not the closure of the regional offices that signalled the change in policy. In fact, the change was implicit in the assumptions about art, standards, excellence, quality and a metropolitan culture that had been built into Arts Council thinking early on, and from which the closure of the English regional offices inevitably followed.

*A tentative new policy: 1956 – 66*
The closure of the regional offices produced an adverse reaction. While the Arts Council argued for its consistency, those involved in the arts in England outside London could not but experience the Council's withdrawal as a concrete expression of its withdrawal from a national involvement in art. As the Chairman of the Midlands Arts Association (founded in 1958) put it in his first annual report:

> Quite suddenly, the office was closed. Our friends departed, and our connection with the Arts Council seemed tenuous — a postal link with some remote body in far distant London, where we felt that no one could possibly understand the problem of Leek, or Loughborough, or Leamington. There were some who felt angry, cheated, or dismayed. [85]

The closure of the Arts Council's Bristol office produced a particularly quick response, art societies in the south-west sending a delegation to London

to seek a measure of financial assistance towards the organization of a body that became known as the South Western Arts Association. The Association was established in 1956 and was essentially a federation of art societies, associations and clubs. The Arts Council's grant went towards the maintenance of arts centres, and the administrative costs of the association. The funding of the South Western Arts Association was the first tentative step in the development of a new regional policy — a step, though, that was hardly recognized as such at the time. The limited recognition given to the Association by the Arts Council was expressed in their 1956–57 annual report: 'The Arts Council continues to recognise the Association as the appropriate channel for grant-aid to its constituent members and to make it a grant for administrative purposes.'[86] Two years after the establishing of the South Western Arts Association a similar federation was set up in the Midlands.

Meanwhile, in 1959, Lord Bridges' report to the Calouste Gulbenkian Foundation *Help for the Arts* was published. In this he noted that 'far too little is done for the arts in the provinces as compared with what is done in London', and he suggested that 'one of the main objects of policy today should be to do something to remedy this glaring disparity'.[87] In particular he suggested that:

> A group of neighbouring local authorities with strong common interests might be willing to join together for an experimental period in appointing an arts officer for the area covered by the whole group. The object of this suggestion is not to recreate anything on the lines of the war-time regional system, but to encourage several neighbouring rating authorities to work together.[88]

While Bridges viewed the experiment as being primarily a cooperation between local authorities, he referred also[89] to the possibility of Arts Council and other support being involved.

Pressure was mounting for the Arts Council to do something more visible in fulfilling its national responsibilities. This pressure, however, was a threat to the basic position the Arts Council had taken. A few further quotations from annual reports will illustrate its stance.

In 1953 the Council asserted that 'Every organisation it assists, large or small, has its own governing body and its self-determined policy.' It added further that 'This respect for self-government in the arts is the main bulwark against *L'Art Officiel*.'[90] '*L'Art Officiel*' was the Council's constant fear. Just as we saw Beresford Hope arguing in the 1860s for a greater State involvement in art in combination with protection from the 'threat' of Government control of art, so with the Arts Council in the 1950s and 1960s a recurrent theme in their reports was the danger of Government (or even Arts Council) control of art. Thus, in 1956 it had been argued that;

Certain local authorities have shown an excess of zeal by providing concerts and plays under their own management, an endeavour which could seem to be — even if not designed as such — a movement towards *L'Art Officiel* and, on that ground, as dangerous as similar provision by a central quasi-governmental body such as the Arts Council.[91]

One of the protections against this danger, in the eyes of the Arts Council, was their policy of response rather than initiation. Thus in 1964 it was argued that:

In the long debate on the relative importance of raising the standard of execution and increasing the accessibility of the arts, it has sometimes been suggested that the Arts Council might more often take the initiative or act as an instigator to stimulate local activity. The Council has in general taken the view that before it intervenes a local demand must be shown to exist, and applicants for Arts Council help must at least take the first steps to help themselves.[92]

This cautious policy of response would, it was hoped, avoid the central problem of State involvement in the arts, which they saw as being the danger of the State eroding the vitality of the individual. It had been stated in the 1961 annual report that:

The paramount trusteeship of the arts in Britain to-day is vested in that percentage of the population which rejects the assumption that sessions of bingo and capers on the Costa Brava are the be-all and the end-all of our new leisure.[93]

For:

The inherent danger in State and municipal patronage is that it could diminish the precious sources of strength which lie in the good citizen's recognition of the value of the arts to a modern society.[94]

In the light of statements like these the impotence of the Arts Council as an organ or instrument of *national* State patronage of and support for the arts in the early 1960s can be well understood. However, a solution was developing. It was developing in the 'half-baked' sense referred to by Keynes, as a pragmatic series of solutions to immediate problems — solutions which were to extend much further the development of the idea of the corporate State in support for and promotion of art.

In 1961 an organization was established in the north-east of England called North East Arts. The organization involved local authority representation and cooperation, both in management and finance. It thus was a development

of the idea proposed by Lord Bridges. As a regional organization set up to support and patronize the arts it also satisfied the Arts Council's demands for local authorities to keep out of the direct management and control of the arts. For North East Arts was, in a sense, a buffer between individual local authorities and arts organizations, just as the Arts Council was supposedly a buffer between national Government and the arts.

The Midlands and South Western Associations that were founded in the 'fifties had been federations of particular societies and clubs. North East Arts, in contrast, could be seen as a vehicle for patronage and support of all arts activities in the area. The Arts Council, therefore, responded enthusiastically to the foundation of North East Arts, and while in 1962 – 3 it gave it a grant of only £500 (the South Western Arts Association was receiving £2,000) the Arts Council finance of the Association leapt annually thereafter to £22,000, £30,000, £40,000, £60,000 and £73,000, up to the 1978 – 9 level of £720,000. Meanwhile the finance given to the South Western Association remained fairly static until 1968 – 9.

While the Arts Council was giving financial backing to North East Arts, the Government took up the theme of regional Associations, arguing in its 1965 white paper *A Policy for the Arts — the First Steps* that:

> A small staff with a few keen local enthusiasts backing them can stimulate the cooperation of other authorities, and by calling on each for a fairly small levy provide funds with which to finance a variety of projects. . . . A network of this kind should be developed to cover the whole country. [95]

As with much in the White Paper, this was more of a vague summary of what was happening than a clear statement of policy for the future. However, with this degree of central Government backing, with Arts Council support for North East Arts, and with Lord Bridges' recommendations for regional organizations, the development of regional arts associations moved forward.

*Consolidation: 1966 – 76*
Regional Arts Associations are non-statutory bodies, registered as charities. Their constitutions, histories and resources vary. However, they are all organizations covering a number of counties; they all involve cooperative funding from a number of district and county authorities (both metropolitan and non-metropolitan); and they all have management bodies or councils on which local authority representation is in the majority, but these management bodies usually also include members from universities, trade unions, arts organizations, and individuals as individuals.

This management body relates to the organisation in much the same way as the Council of the Arts Council relates to its organization. Beneath the management body are full-time officers for the various arts; these officers are served by a number of committees and panels, which comprise various individuals professionally or otherwise involved in the particular art form.

Part of the finance of an RAA (Regional Arts Association) comes from the

member local authorities. However, although the Arts Council has occasionally tried to establish a principle whereby it contributes on a matching pound for pound basis, in practice the larger share of RAA finance usually comes from the Arts Council of Great Britain.

In the 1966–76 period a network of RAAs was established all across England. Lincolnshire (later to include Humberside) had been established in 1964; the North West Association was set up in 1966, and further associations were established until 1973 when the last English RAA, South East Arts, was founded.

There are now twelve RAAs in England, covering the whole country except for part of Buckinghamshire. Scotland has no RAAs; Wales has three but as they are different in kind, function and size from the English, we shall leave them out of this discussion. The South Western Arts Association and the Midlands Arts Association, which we referred to earlier, have both been reconstituted according to the model described above, the Midlands Association in the process being split into two — one for the East Midlands and one for the West Midlands.

In 1961 it had been declared in the Arts Council's annual report published that year that: 'Patronage should disclose, so to speak, a molecular structure of representation; it should be shared by individuals, local and central government, voluntary bodies, industry, and the universities.'[96]

The network of RAAs, in association with the Arts Council, represented a consummation of corporatism. That consummation, however, had been neither planned nor expected at Arts Council level. Arts Council annual reports are the main vehicle via which the policies of the Arts Council are communicated to the public. Clear policy, however, has never been a characteristic of the Arts Council of Great Britain, and those sections of the annual reports that can be read as 'policy' (those parts of the text signed by the Chairman and the Secretary General of the Arts Council) are generally more in the style of mini homilies, than any clear declaration of programmes or intentions. While the annual reports, therefore, betray an awareness of the growth of RAAs, the actual arrival, in the 1970s, of what looked strikingly like a national network of regional bodies, took the Arts Council by surprise.

*Confusion: 1976–81*

In 1971 Hugh Willatt, Secretary General of the Arts Council, described Regional Arts Associations as 'a systematic partnership between a large group of local authorities, designed to develop and maintain artistic activity and appreciation throughout a whole region'.[97] This neat and systemic definition was optimistic. The RAAs were, in financial terms, a 'partnership' between the Arts Council and local authorities. However, the levels of funding, and the proportions contributed by the two sides, varied and varies greatly. The scope and responsibilities of RAAs is similarly varied, as is the direct contribution of the Arts Council of Great Britain to artistic activity in the various regions. The system developed pragmatically, and it now operates with an inheritance of *ad hoc* developments.

Willatt's definition was also too neat, however, because the development of

the RAAs poses a threat both to the authority and role of the Arts Council, and, to a lesser extent, to the definitions of art and culture which the Arts Council has fostered.

The RAAs pose a threat to the role of the Arts Council because their existence demands clear thought on the division of functions between the national body and the regional bodies. The RAAs have specialist staff; they have specialist advisors; they should have a more detailed knowledge of their region, its potentials, needs and resources, than the Arts Council. The threat posed to the definitions of art and culture fostered by the Arts Council is more complex, and less strong. It follows from the challenge to a 'national' notion of quality, standards and excellence (as interpreted in terms of a given tradition) that is posed by regional organizations who *may* be more committed to the idea of art and culture as a developing and continuously remade practice.

John Maynard Keynes, in his 1945 BBC Home Service Broadcast[98] on the Arts Council had declared;

> How satisfactory it would be if different parts of this country would again walk their several ways as they once did and learn to develop something different from their neighbours and character-istic of themselves. Nothing can be more damaging than the excessive prestige of metropolitan standards and fashions.

Keynes did not downgrade London. In fact he said 'It is also our business to make London a great artistic metropolis, a place to visit and wonder at'. But there is implicit in his comments the idea that a 'national' tradition of art could and should be the sum of its parts; that a vital culture is one that is alive through its diversity; and that London, as the national centre, could reflect the diversity of the nation's riches.

As we have noted, this was not the vision made concrete in the practice of the Arts Council. The Council had fostered and adhered to the notion of art and culture as a received tradition within which the idea of 'excellence' and 'standards' was set in opposition to concepts such as 'diffusion', 'local' and 'regional'. Within British socio-political language words such as 'parochial' have acquired derogatory connotations and it is within the terms of such a vocabulary that the Arts Council had come to represent ideas of professionalism and excellence within a national context — a 'national' context, however, that was not the sum of the nation's parts, but related more to an abstract understanding of a tradition that was and is separate from the developing practice of art within Britain.

It is to this tradition that the RAAs pose a threat. The threat follows not from any clearly articulated sense of an alternative understanding of art presented by the councils, committees or officers of the RAAs; rather, it is implicit within their existence. For in their nature they cannot gain success and reputations entirely by working within a received and 'national' view of art. In the long term, they have, as regional bodies, to gain some of their reputation and distinctiveness through their differences — through the

63

practice and vitality of the art which they support in their own regions.

The Arts Council's response, however, has been cautious. Roy Shaw, when Chairman of the Arts Council's Regional Committee, said to a 1974 conference on *Arts in the Regions*, that 'the situation before us is confusing, and to me it seems likely that anyone who is not confused is not taking the measure of the situation.'[99]

Lord Feversham, who at the time was Chairman of the Standing Conference of Regional Arts Associations, described the Arts Council's attitude to RAAs before the same meeting as 'cautious in the extreme in every sphere other than finance', and he went on to add:

> I cannot remember a time when I have had the feeling of being received at the Arts Council as a colleague involved in the same business. Rather one is given the feeling that one is some kind of orange, three headed martian with antennae sprouting from the forehead who has just landed by flying saucer in Green Park.[100]

The confusion and the lack of understanding have hardly been resolved in the intervening period. The main development has been a continuing argument (from the Arts Council side) for what is in effect an integration of the RAAs into a system dominated and controlled by the Arts Council. Thus in the thirty-second annual report of the Arts Council it was reported that a working party, set up to review the issue of devolution of power and responsibilities from the Arts Council to the English RAAS, had concluded that:

> The next steps along the road to decentralisation lie in a strengthening of the partnership with RAAs, rather than through the immediate transfer of responsibility for grant-aid of many more clients at present funded by the Arts Council. A number of ways of re-inforcing co-operation were proposed, of which the most significant was that RAAs should be encouraged to join with the Arts Council in the assessment of regional organisations. The Council wishes to give every support to this aim.[101]

'Partnership' and 'cooperation' are the key words here — a partnership and cooperation which would tie the workings of RAAs more closely into the national system. The Arts Council's 1978–9 report, in the section on 'Regional development' reinvoked the idea of a 'molecular structure of patronage' combining all manner of interest groups, authorities, levels of government, local, regional and national bodies. The RAAs, in terms of present Arts Council thinking, fit into this pattern.

## The National – Regional Tension

Throughout its history, therefore, the Arts Council of Great Britain has worked with a built in tension between various meanings of a 'national' role and other ideas concerning 'regionalism' and 'localism'. These tensions,

while at one level centring on administrative questions (which is the most appropriate level at which to administer State patronage of the arts?) have been closely bound up with the politico-cultural vocabulary of British society. Within this vocabulary a fine art tradition is understood as an inherited collection of practices and meanings to be nurtured apart from the mainstream of British social and political life; 'tradition' is linked to notions of 'national' and 'professional', these concepts being set against ideas of 'regional', 'parochial' and 'amateur'; and the idea of the fine art tradition is linked to ideas of 'freedom' and 'initiative', these being set in opposition to ideas of 'planning', 'policy' and 'organization'.

## The Arts Council and the Visual Arts

The practices of the art department of the Arts Council have, of course, been part of and shaped by the policies and practices of the Council as a whole. Visual art has been subject to the general definitions of art and culture established and reproduced by the Arts Council. However, within the art department practices have, in various interesting ways, differed from those adopted by other departments, conforming more to models established by the Department of Science and Art in the nineteenth century, than to the models established by the major spending departments of the Arts Council — music and drama.

In the 1940s and 1950s, as we noted, the Arts Council adopted the argument that it should 'respond' to the initiatives of others, rather than take initiatives itself. This line has been generally followed by all departments except for art. In all other departments a very high proportion of expenditure is spent as grants and guarantees to other 'independent' organizations. In the art department, however, around half the department's expenditure is spent on activities directly controlled or organized by the department itself.

The largest demand on art department expenditure is the production and touring of the department's own exhibitions. Additionally, the Arts Council of Great Britain in England directly manages two galleries: the Hayward Gallery and the Serpentine Gallery.

Aside from running its own galleries and creating and touring its own exhibitions, the art department makes revenue grants to about fifteen independent galleries and about five further organizations; it makes available grants to other galleries to assist with the costs of particular exhibitions; and it provides assistance for approved schemes involving the commissioning of public works of art.[102] The making and touring of exhibitions, with the running of the Hayward Gallery, however, is the largest item of art department expenditure.

For reasons which are far from clear, in the 'forties and 'fifties, when the Arts Council was dismantling the direct provision operated by CEMA in the Second World War, it was accepted that the art department should continue to create and provide exhibitions. An argument was made that no other organization was able to provide such a service — but an equivalent argument

could have been made for aspects of the work of other departments. Further, while the major 'national' companies funded by the Arts Council in the performing arts are all independent companies, when the Hayward Gallery became available as a major 'national' venue for temporary exhibitions, it was not constituted as an independent company, but was taken under direct Arts Council control as a directly managed space.

At the level of its distribution of grants, guarantees and awards to other organizations and individuals the art department acts in the same way as other departments. There is no general or argued policy as to how institutions and funds should be geographically distributed; there is no general analysis of national or local needs, resources and facilities; no guidelines exist other than the response of the department and its committees to 'initiative', 'quality' and 'excellence'.

It is, however, the art department's practices in both creating exhibitions and managing galleries that so closely conform to patterns established in the nineteenth century.

In looking at the development of art schools we noted the pattern whereby Government ran a National Art Training School (now the Royal College of Art) in relation to a number of provincial art schools which were nominally independent of central Government, although controlled through the allocation of partial Government assistance, and the control implicit in the inspectorate and payment by results schemes. Meanwhile, in looking at museums we noted the establishment of what is now the Victoria and Albert Museum as a central, directly run 'model' institution, while local museums of art were only encouraged and controlled through national legislation. Meanwhile, the Victoria and Albert Museum ran a travelling exhibition service which made available centrally produced exhibitions to local art schools, museums and other venues.

The practices of the art department of the Arts Council have developed along very similar lines. It runs directly a major ('model') exhibition venue and it creates and tours exhibitions. Further, in making available grants to approved provincial institutions (both for general revenue purposes and for particular exhibitions) the Arts Council relates to provincial institutions in a way very similar to that existing between the Department of Science and Art, the National Art Training School and provincial Art Schools in the nineteenth century.

This parallel between nineteenth and twentieth century developments is not accidental. Both are rooted in the same desire to promote a particular form of culture, without appearing to dictate cultural practices. In both, State organization controls through the structuring and shaping of opportunities, rather than through any apparently direct and overt interference. In both, the structuring and shaping of opportunities (effected through the control of resources and the use of various assessment procedures and inspectorate systems) is complemented by a degree of 'model' provision.

# Politics and the Corporate State

It is conventional wisdom that over the past two centuries there has been a steady and progressive growth in political democracy, opportunity and socio-economic equality. The right to vote is no longer determined by wealth, property or sex; basic education is compulsory for all up to the age of sixteen; further and higher education is generally available on merit; a health service is provided out of public taxation; and old age pensions provide some cushioning against the financial insecurities of old age.

These developments have been part of the development and expansion of the State which is interwoven with the growth of commerce and industrialization, and which is also a response to the extension of representative democracy.

In a society where most adults over the age of eighteen have the right to vote it is politically difficult to limit education on the basis of wealth, sex or class, just as it is difficult for a Government to tolerate for long any substantial minority of the population living in a state of obvious and visible poverty, homelessness or unemployment. What constitutes a 'substantial minority', however, and what constitutes open access to education, are negotiable issues — the negotiability of the issue depending on what are generally accepted as being the causes of the problem and the practical powers of government in dealing with it.

The three decades following the Second World War were a period of considerable optimism concerning social, economic, political and cultural issues. The Arts Council of Great Britain's first annual report quotes John Maynard Keynes as saying:

> The day is not far off when the Economic Problem will take the back seat where it belongs, and the arena of the heart and the head will be occupied, or re-occupied, by our real problems — the problems of life and of human relations, of creation and behaviour and religion.

This is the context within which post-war expansion took place; within which the National Health Service and an expanding education service were developed, and upon which the boom of the 1960s was built — a boom within

which social and economic problems were seen as short-term issues that could be overcome through an adequate programme of public expenditure and the creation of the appropriate public services.

The economic boom and social optimism were both the basis for and expressed through a flowering of technocratic, managerial and professional ideologies and practices. For, in terms of these approaches, social, economic and cultural problems are seen as individual, immediate and short-term problems having technical solutions. Thus problems of poverty, broken homes, child welfare and homelessness led to a response in the form of professionally trained and qualified social workers — persons seen as having the appropriate expertise to administer the solutions to the problems. On a different level, within both the education and health services reorganization took place leading to the organization of disparate units into larger institutions and regions organized and administered according to a managerial ethos — i.e., a clear separation developed between the functions or purposes of institutions, and their management and administration, the latter becoming a specialism in itself.

The growth of management and administration as a skill and profession in itself and separate from that which is being managed has been paralleled by a flourishing of professional qualifications. Recreation managers, town planners, teachers and arts administrators are examples of occupations where specialist courses and qualifications are increasingly emphasizing the professionalism of the group. It is, for example, no longer sufficient that a teacher of French has a degree, fluency in the language and knowledge of the literature of France. A separate teaching qualification is also required, this qualification emphasizing a separation between the knowledge necessary for teaching, and a set of separate skills argued as necessary in order to share the knowledge.

The development of managerial, technical and professional specialisms was not, of course, new to the post-war period. The three decades following the Second World War saw, however, a flourishing, expansion and acceptance of these ideologies and practices on a new scale.

One of the most important expressions of these tendencies was the reorganization of local government that took place in 1974 — a reorganization within which the *ad hoc* development of a local government system based on and tied into place, town and community was displaced by a system organized first according to ideologies of management. Under the new system (as part of which the total numbers of democratically elected representatives was severely reduced) the primary concern was the most effective way of organizing the provision of services. The democratic control of local government through elected representatives was marginalized in relation to an administration at county and district levels within which the professional officers increasingly play a dominant role.

Paralleling these developments, of course, has been the growth of regional and national bodies outside the direct control of Parliament or local authorities, and taking on functions formerly the responsibility of Parliament or local authorities. It is often forgotten today that some local authorities used

to be involved in the provision of water, gas and electricity — all now managed by regional and national specialist organizations. A more recent instance of the transfer of responsibilities is the development of an administration of hospitals and health on a regional basis.

These and other developments are instances of a depoliticization of Government: a process whereby large areas of public administration are removed from the arena of political debate and control.

## The erasure of politics

We referred in Chapter six to the senses in which the quango model of State organization made private that which State intervention had apparently made public. Within the quango model policy, debate and control is made the province of whatever body of councillors, managers or trustees have power vested in them, and whatever groups of advisers, experts and officials are brought in to assist or work for the controlling body. The quango model incorporates both a technocratic and a professional ideology. It assumes either that whatever area of work is given to a quango is a matter too complex to be handled by any group other than those professionally trained in or knowledgeable about the matter; or that the subject concerned is merely a technical matter which can be implemented by a non-Governmental body without reference to political debate. Many quangos are based on an intermixing of these two.

Whatever the nature of the quango, it is fundamental to it that it is based upon the depoliticization of that aspect of public activity. This depoliticization is inherent generally in the development of a professional and managerial ethos both within the direct organization of central and local government, and within non-governmental agencies set up and/or financed by Government. Depoliticization of areas of public life, however, reaches its extreme in the quango.

Politics, in an open or democratic society, could or should be about the public formulation of programmes in pursuit of objectives elaborated through public debate. In a representative democracy that process can, in a democratic sense, take place only through interchanges between members of the governing body and between those members and their electorates. Popular democratic control over public policy, to whatever extent that is achievable within a representative democracy, can take place only through the relationship of MPs to their electorate and to Parliament, and through the relationship of local authority councillors to their electorate and to their Councils.

To the extent that areas of public administration, Government work, and public expenditure are removed from the control of Parliament or local government, those areas are removed from the democratic political process.

One effect of this has been that, while on the one hand the scope of representative democracy has been extended in Britain through the extension of the franchise to most adults over eighteen, on the other hand the

effectiveness of that democracy has been reduced. Aspects of public policy as divergent as tourism, broadcasting, the arts and industrial investment are handled by councils, boards and corporations constitutionally separate from government and Parliament. Public debate does, of course, take place concerning all these matters — as does Parliamentary debate — but these debates are not tied into the only direct and democratic political process that exists in Britain.

## The State and bureaucracy

Libertarianism and individualism have been strong elements in the British political and intellectual traditions. These traditions have played an important part in the development of the British State, particularly in the ambivalent attitude towards politics within the British State. 'Politics', in a negative sense, is often seen as being to do with economic management, utilitarian matters, and international relations. In an even more negative sense politics is sometimes seen as being to do with the careers, ambitions and arguments of a particular group of individuals who are members of political parties and seek work as 'politicians'. In this most negative sense the idea of politics is made both private and exclusive: politics is seen as being to do with a particular professional group who have careers in politics in the same way that a doctor may have a career in medicine.

While politics and politicians have been sometimes viewed in these negative senses, the idea of 'Government' has equally been subject to the same ambivalence. The ambivalence towards the idea of Government follows partly from it being to do with politics, but more generally the idea of 'Government' is viewed negatively when linked to the idea of 'bureaucracy' — 'Government bureaucracy'. The idea of 'Government' by itself has, in fact, some very positive connotations. A politician, as a member of Government, may, for instance, be perceived as a 'statesman'. Nevertheless, as a statesman, a politician may still take actions which lead to a negatively perceived extension of 'Government bureaucracy'.

A 'bureaucracy' is seen as a mechanical, dehumanized organization, governed by rules, procedures and formalities which take no account of irregularities, differences and particularities. It is understood as being insensitive to subtlety, to value and to traditions. A 'Government bureaucracy' is seen as having all the force and power of Government, without any of the subtlety or responsiveness of an individual.

Libertarian and individualist traditions have stood for ideas of liberty, freedom, value and individuality in opposition to both the power of Government and the formality of bureaucracy. At its most radical the libertarian tradition is critical and dissenting; it is the tradition within which democratic rights and freedoms have been fought for and established. At its more conservative, however, the libertarian, liberal and individualist traditions are also those within which and through which the established professions, professional, business and intellectual classes, have asserted both

their involvement in and separation from Government and the State. As two examples of this we have quoted Beresford Hope, a mid-nineteenth century MP, talking of it being 'fatal' if 'whatever Government attempts on behalf of art . . . were to lead to free opinion and free work being subordinated to bureaucratic authority'; and John Maynard Keynes' assurances in 1945 that, in establishing State intervention in the arts through the Arts Council, 'we do not intend to socialise this side of social endeavour'.

## The individual, policy and politics

A suspicion of and ambivalence towards Government, bureaucracy and the State, and an assertion of human, individual idiosyncratic and varied values, has been the positive contribution of libertarian and individualist traditions to the development of the State and British Government. Its negative contribution has been the lending of intellectual support to the development of State institutions that are undemocratic, that operate often as private clubs for particular professional, intellectual and interest groups, and within which 'politics' have been erased

Roy Shaw, as Secretary General of the Arts Council of Great Britain, stated approvingly in the thirty-fourth annual report of the Arts Council that;

> Lord Goodman, when he was Chairman of Council, said he had never heard a political discussion at any Arts Council meeting, and it seemed to him inconceivable that one should take place. That is still true, much as it may surprise both those who see the Arts Council as the tool of the ruling class and those who believe it favours left-wing arts.

This apolitical (almost anti-political) stance has been true of the Arts Council since its foundation, and is connected with the difficulty the Council has always had in formulating policies towards the arts — or at least the difficulty it has had in formulating policies that are more than the accretion of *ad hoc* decisions. 'Policy' is to do with 'politics'; the latter is the art of creating the former. The former is created through a political process.

Shaw and Goodman, of course, were using the word 'politics' in one of its negative senses. They were using the word in the way that some Government and Opposition spokesmen are liable to do when, in a radio or television interview, they emphasize the importance of a point they are making by saying that they are *not* making a 'political' or 'party' point. Conceptually they separate two levels of debate: a debased 'party' or 'political' debate, and that involving 'real' and 'true' emotions and observations. Through the acceptance of such a separation the idea and possibility of politics as being to do with the formulation of public policy is itself debased.

The acceptance of a debased view and understanding of politics is illustrated in two quotations from Roy Shaw as Secretary General of the Arts Council in the Council's thirty-second annual report. In the first quotation he

71

first separates the Arts Council from the idea of politics through identifying 'politics' with 'party-political strife', and then goes on to describe Arts Council policy in essentially technocratic terms:

> It is sometimes argued that the Arts Council's support is mainly for arts enjoyed by the middle class, and that this is incompatible with, for example, a socialist policy for the arts. For many years arts policy has been substantially bipartisan in its general thrust, and it would seem a retrograde step for it to become a battle-ground for party-political strife. Both the main parties have accepted the need . . . to make the arts accessible to a larger proportion of the population. It should be clear to all parties that the main obstacle to a fuller achievement of this policy is the lack of sufficient funds to develop new programmes in several directions.

In this statement the arguments hinted at in the first sentence are not answered. The second sentence, which appears to answer the arguments of the first, in fact only comments on the general approaches of Labour and Conservative parties to the Arts Council, while asserting that it would be 'retrograde' if the two main parties were to debate arts policy from their respective positions. The technocratic element in the statements follows in the third and fourth sentences where, having apparently dismissed political debate from the arts, the implementation of an arts policy is stated to be purely and simply a matter of money. That is, the Arts Council is presented as a body whose only problem is to find sufficient resources to implement a goal which would be in an unproblematic sense, achievable if resources were forthcoming.

It was once thought that Britain's housing problem could be solved by a combination of knocking down old and substandard property and building a sufficient number of new dwellings. The housing problem, in other words, was a problem whose solution lay in provision and resources. What Roy Shaw said about the Arts could, and probably was, said about housing: 'The main obstacle to a fuller achievement of this policy is the lack of sufficient funds to develop new programmes in several directions.' However, in housing this did not work. It may be true that sufficient funds at the level necessary were never made available, but it was found that equally important were questions of what types of housing were developed; whether they were developed privately, by local authorities, or by housing associations; how house occupiers related to their houses, their environments and communities; how people from demolished or redeveloped areas related to where they were rehoused, and so forth. In other words social, cultural and political issues began to rear their heads in housing policy. There was no such thing as a bipartisan or apolitical approach. There could be no subordination of the necessary debate, analysis, policy-making and questioning (necessary in any political process) to some technocratic notion of an obvious solution requiring only money.

Our second 'political' quotation concerns the Arts Council's response to political criticism. Shaw stated that:

> The Council is from time to time criticised left and right, but not yet from the centre. As a 'buffer' between politicians and artists, the Council expects to be buffeted by both sides, accepting it as an occupational hazard. In any case, some of the attacks cancel each other out. For example, the Council is criticised from the right for giving grants to avowedly socialist theatre groups. At the same time it is criticised on the left as the tool of the ruling class with a bias against left wing groups.

The assumption here seems to be that it is somehow good and worthy to be attacked from both left and right because this is assumed to demonstrate the essential moderateness and equilibrium of the Council. 'Politics' here is avoided by being presented as a self-defeating process which cancels itself out. Implicit in this statement is an anti-intellectualism which can easily follow from the denial of politics and policy. For, in so far as intellectual debate takes political forms (is expressed in political argument) the sidestepping of such argument (left cancels right, therefore we are neither) can lead to a refusal to engage in, and therefore a denial of, serious political *and* intellectual discussion.

## The management of consensus

Raymond Williams, in an article on 'The Arts Council'[103] has noted that the ability of the British State to delegate some of its official functions to intermediate bodies, councils and committees has followed partly from Britain having 'an unusually compact and organic ruling class'. He noted that the State can 'give Lord X or Lady Y both public money and apparent freedom of decision in some confidence . . . that they will act as if they were indeed State officials'.

Underpinning this process are a number of procedures including what Williams calls 'administered consensus by co-option', this phrase referring to the procedures whereby, in the case of the Arts Council, members are selected and appointed via an informal series of consultations between senior members of Council and the Department of Education and Science — the latter, of course, having the final authority. He suggests that what 'begins, from a Department of State, as a process of selective and administered consensus, cannot become at any of its lower levels an open and democratic public body and procedure.'

The Arts Council, Williams notes, 'is politically and administratively appointed, and its members are not drawn from arts practice and administration but from that vaguer category of "persons of experience and goodwill" which is the State's euphemism for its informal ruling class'.

It is in terms of this co-option on to State organizations and institutions of

members of an informal but compact ruling class that we must understand the erasure or denial of politics that we have been discussing. Williams, from his experience of a three-year membership of the Arts Council, talks of a 'mood of bewildered benevolence' and a 'consensus of goodwill' as characterizing the Council. Such a characterization of the atmosphere of the Council is reminiscent of the artistocratic and upper middle class traditions of 'good works', 'public duties' and paternalistic benevolence towards the poor. And it is, of course, precisely this tradition — whatever the social class composition of quasi-independent public bodies and authorities — that is carried over into the style and mode of operation of public councils and committees under the quango model. Equally important is its 'private' character deriving from a tradition of private aristocratic and upper middle class munificence and benevolence in public matters. It is part of a tradition of *private* individual 'public' generosity.

This tradition of 'men of goodwill' acting together in the 'public interest' precludes and denies the processes of public debate and policy making which could and should be part of an open and more democratic system of public patronage. Consensus (operating to deny and dampen debate) dominates. Raymond Williams once described, at a special meeting of the Arts Council, something of the relationship between the British State and its informal ruling class, applying his argument to the Arts Council. He recalled:

> When I described these processes at the special conference and applied them to the Arts Council I was told, hilariously, by the present Vice-Chairman, that I did not understand 'participatory democracy' (a phrase, by the way, which I seem to have invented in 1961, to describe something very different) and that it was by this process that we achieved 'the essence of democracy', which was — no need to guess — 'consensus'.[104]

## Closure and the status quo

The political and social strength of quasi-independent semi-autonomous government agencies and institutions follows from, and is based upon, the confusion of a system within which advisers, public figures and members of interested organizations are co-opted on to such bodies, with a notion of participatory democracy and openness. The Arts Council, as one variant of the quango model, has included on its advisory panels and committees over the years many hundreds of artists, art critics, art lovers and administrators. It has incorporated within itself some of its most ardent critics. In no sense can it be said that the Council has failed to consult a wide range of specialist and expert opinion. It is not the broad range of advisers and Councillors that specifically dictates the character and style of the organization, although this plays a part. It is, rather, the modes of selection, the relationships of committees, panels, Council and officers; the rules of confidentiality and secrecy governing the matters discussed at meetings of panels, committees

and Council; and, crucially, the uncertainty and individuality governing both each panel and committee and the Council members' relationship to the whole organization.

Uncertainty and individualization are two key principles in the workings of the Arts Council, underpinning the difficulties it has in articulating and coming to terms with the need for clear public policies towards the arts. 'Uncertainty' and 'individualization' govern in particular the relationship of panel and committee members to the organization — but also affect Council members.

Individualization follows from members of panels and committees serving specifically and only as individuals. This position is made clear in the letter inviting individuals to be members of committees or panels; in no sense is an individual to be seen as representing or speaking for any organization or group. While on one level this has the advantage of making all committee or panel members theoretically equal (the chairman or president of an association of 500 sculptors in theory carries no more weight on a panel than one individual sculptor) it also emphasizes a dislocation between the panel or committee member and that member's role or position in the world. Committee and panel members serve, in a sense, 'naked'; within committee and panel they remove their public clothes, and become one individual among other individuals.

This individualization of panel and committee members is, of course, in conflict with the actual practice of appointment, for it is common to find on the art panels and committees of the arts councils senior members of major institutions, well-known critics and art educators. Individuals are very specifically chosen for their public position and standing. In fact, the emphasis on members serving as individuals serves not to deny the public position of particular individuals but rather to exclude any alternative power base constituted through any form of collective organization. That is to say, individual or hierarchical authority is represented on panels and committees; collective authority is not. An example may illustrate the point.

The Director of the Art Department of the National Museum of Wales is a member of both the Council of the Welsh Arts Council and of the Welsh Arts Council's Art Committee. He serves as an individual, but, as an individual, he is also Director of the Art Department of a National Museum. He is head of hierarchial structure, and, as an individual, can speak for or about his department of the museum. He is not a member of the Council and its Art Committee in order to 'represent' the museum, but, given that within the museum he is part of a command structure where authority runs from the top down, he carries, as an individual, the authority vested in that job.

Meanwhile in Wales there exists an organization called the Association of Artists and Designers in Wales. It is a cross between a trade union and and artists' association in organization. In many ways it acts as a trade union for artists, making representations to public bodies and institutions on behalf of its members. It is organized democratically, according to trade union principles.

The AADW cannot be represented on the Welsh Arts Council or its Art

Committee. Individuals who are members of the AADW are often also members of the Art Committee but the exclusion of representatives of organizations as such precludes any formal recognition within committee of that form of collective power.

Thus the individualization of panel and committee membership allows for the inclusion and recognition of an individual's power and authority where and when that is vested in him as an individual as part of a hierarchical or command structure. But it can exclude forms of authority and power which flow from a democratic and collective base — as in the trade union model.

The principle of 'uncertainty' is more complex. The uncertainty is built into committee and panel members' relationship to the Arts Council. Panel and committee members are *invited* to serve. The real procedures whereby an individual is invited to serve (i.e., how a person's name comes up for consideration; on whose recommendation; by what formal procedures, if any, are likely members of committees and panels investigated and discussed) are vague. There is no clear and defined formal process for selecting members. The member is invited formally by the Council through its senior officers. Therefore the individual's position on committee or panel is only by licence of the Council and, in a sense, at the pleasure of the Council. The individual is invited to serve for one year; reappointment for the following year is likely, but not certain.

The panel or committee member then becomes part of a group that is, constitutionally, 'advisory' to Council. In practice Council will generally accept what panels and committees decide, but the formal advisory status of committees and panels emphasizes an ambiguity and weakness in the panel or committees' position. The panel or committee is a group of individuals proffering 'advice' to the Council. The individualization of panel or committee members, combined with this ambiguous relationship to Council, can, and often does, lead to an informality in the procedures of committees and panels — that is, it can lead to a search for the consensus among a number of individual opinions, rather than establish through formal debate, discussion and *voting* any strict divisions or balances of opinion.

Committee or panel can become in these senses more of a sounding board for officers than a body with a grip on actual decisions, policies and procedures. To what extent the panel or committee is treated as an executive body, and to what extent it is treated as a 'sounding board', depends very much on the individual departmental officer or the panel or committee chairman.

Meanwhile, while there is uncertainty built into the individual's relationship to and membership of committees or panels, and uncertainty in the panel or committee's formal relationship to both Council and officers, Council itself relates uneasily to panels and committees. In formal terms Council is the body that creates policy and takes decisions. In practice it accepts at its meetings a mass of papers, documents, recommendations and suggestions from the committees and panels of all departments in such quantity that a scrutiny of all decisions is impossible, even were it desirable. Council can scrutinize and debate some issues, but these form only a small part of the

organization's entire business.

In practice and in general it is the officers of the Councils — the permanent, employed staff — who make decisions, create policy through the accretion of decisions and structure the meetings through their provision of information. But, in formal terms, officers work on the direction of Council, which works on the advice of panels and committees. In formal terms the officers do not create policy. In so far as they do take decisions, these are formally within the guidelines and policies laid down by Council on the advice of panels and committees. The real work, position and power of officers is hidden behind (or lost within) the formal structure of the Council.

The difficulty of public debate with or about Arts Council policies and decisions follows from the uneasy mix of authorities and powers implicit in this system. Formal power rests with a Council, most individual members of which will be unfamiliar with the workings or policies of individual departments. Panel and Committee members are bound by rules of confidentiality which preclude outside discussion of business. Officers, who do know and understand most of the business of their own departments cannot comment publicly upon it as they are formally subordinate to Council.

While, therefore, at one level Arts Councils may appear open and informal, and while they certainly do consult a wide range of specialist individuals on approaches to the various art forms, a denial of openness is built into the system — is built into both the relationship of advisers to the organization and into the relationship of the organization to the public.

Individual officers can and do attempt to work against the forms of closure, imprecision, lack of clarity and lack of policy built into the system. But in doing so they generally have to work against, or in spite of, the nature of the organization.

## Politics and the corporate State

This chapter opened on a general level with an examination of broad tendencies as they have developed in the British State. We have ended on a more particular level, examining something of the internal organization of the Arts Council. Two main themes, however, have run through both the general and particular discussion: first, the erasure of politics within certain types of State formation; and second, the ways in which varieties of individuals from various specialist and interest groups are incorporated into semi-independent governmental organizations. In discussing the erasure of politics we have examined the ways in which this is related to a denial of policy and clarity. This denial is in turn related to various forms of administered informality built into the quango model, to the nature of the British ruling classes, and to the forms of aristocratic and upper middle class traditions of public work and responsibility.

In discussing the incorporation of individuals and members of various specialist and interest groups into the State organization we have traced some of the ways in which real debate and democratic involvement are denied

through the workings of organizations which are sometimes confused with an idea of 'participatory democracy'.

We have also touched on the professional, managerial and technocratic ideologies that relate to and are part of the negation or marginalization of open and public debate, these ideologies and practices being substituted for the political processes which would be an essential part of an open and democratic formulation of public policy.

# Politics and Policy

A Labour Party policy background paper issued in 1977 called *The Arts and the People — Labour's policy towards the arts* noted correctly that:

> In so far as most works of art are concerned with man as subject matter — his ideals, beliefs, fears, joys — they are inevitably political in content. It is difficult, not to say impossible, to tell a story which does not take an attitude — either questioning or reassuring. Such an attitude may be implicit or explicit but it will be there and the cumulation of such attitudes is political. In the same way, where you present a work of art, how much you charge for it, what forms receive subsidy, will have an inevitable political effect.

This is an obvious point. The denial, trivialization and marginalization of it, however, has been implicit in the development and shape of State involvement in art in Britain. The denial of the point is implicit, for example, in a statement from the Arts Council's thirty-second annual report, where it is asserted that 'It should hardly be necessary to reassert that the Council makes its assessment of arts activities solely on grounds of artistic value; but it seems that it is.' [105]

Here a notion of 'artistic value' is elevated and reified to a point where it denies all other issues. In itself a notion of 'artistic value' — even as an exclusive issue — does not necessarily deny issues of artistic content, patronage, politics, presentation, policy and planning (the whole constellation of issues that should properly be the concern of a public body concerned with the patronage of the arts in a socially and culturally mixed society). In practice, however, concepts such as 'artistic value', 'standards' and 'quality'; the individualization of Arts Council procedures; the style of aristocratic benevolence implicit in the organization of the Council; the apolitical or anti-political stance of the Council; all this has involved a denial of the constellation of issues and approaches which a proper understanding of the social and political nature and contexts of art would necessitate.

However, an issue raised by the quotation from the Labour Party document just cited is the exact meaning we ascribe to the word 'politics'. Thus far in our discussions we have been using the word in a narrower sense than that employed in the Labour Party document. In that document the idea refers to all attitudes and beliefs concerning people's relationships one to another, the nature and structure of society, the position of men and women in society, the values of that society and the exercise of power within society. This is the broadest and fullest sense of politics as being to do with power, and the relations, values and exercise of power.

In this book thus far we have tended to use the idea of politics in the narrower sense of being to do with the formulation and implementation of policies, and the use and exercise of power, within the public or political domain.

Both uses are, of course, current, and thus correct, though the second, and narrower, usage can only be fully understood in relation to and as derived from the former, fuller definition.

State involvement in art has, of course, always been 'political' in both senses. The involvement of the power and authority of the State in art is directly political in the narrower sense, since it involves the exercise, in the public sphere, of public, political, State authority towards particular ends. Equally the involvement of the State in art is directly political in the broader sense, since the exercise of that authority is wrapped up in values, decisions, attitudes and assumptions concerning people's lives, experiences and social relations.

Equally, of course, the denial of politics and the relevance of political issues and approaches to State patronage of and involvement in art is itself a political fact and attitude, for an understanding of the anti-political stance implicit in the quango model of State intervention is fundamental to an understanding of the politics of such organizations.

In this chapter we shall concentrate on four related issues concerning the politics of State intervention in art.

First, taking up the broad approach to the idea of politics indicated in the quotation from the Labour Party document on the arts, we shall examine a series of statements from Arts Council reports, these statements being illustrative of a political stance conveyed through what is overtly a moral argument. Second, approaching the subject from a very different angle, we shall examine the financial organization of State patronage of art — the apparent chaos of the routing of money being in fact a practical expression and consequence of the anti-political ideologies implicit in the quango model and the separation of powers argument.

Third, we shall explore the pressures towards the establishing of a Ministry of Culture — that is, pressures towards the politicization of State intervention in art.

Fourth, we shall explore the tendencies in Scotland and Wales for the counteracting expressions of national identity to lead to a greater politicization of State intervention in art within those contexts.

# The morality of art

In discussing the development of State involvement in art in the eighteenth and nineteenth century we noted one aspect of State power and authority which can be called 'moral' power and authority. We discussed the State as a 'moral' force — a discussion particularly relevant to an examination of State involvement in art given the moral good and value often ascribed to art.

Political discussions, of course, are often presented in terms of moral arguments, for moral arguments appeal to general values — to values it is assumed or suggested we all accept.

The moral arguments of any period often look shallow or hypocritical to subsequent periods. It has been customary, for instance, to see Victorian society as hypocritical for declaring an adherence to moral codes and values which were frequently broken in practice, or which were based on unfounded assumptions about the world and social behaviour. The inadequacy of the morality expressed by the dominant classes in one period in the eyes of subsequent generations, however, often follows not so much from a change in values or practices as from a change in language. The language with which various classes justify and maintain their position is far more subject to change than the positions of the classes themselves. Thus, as we have noted, an essentially aristocratic and private form of arts patronage, exercised through the Arts Council of Great Britain, can today be described as 'participatory democracy' — a formulation clearly in tune with the values of the late twentieth century, although clearly inappropriate as a description of the style and organization of the Arts Council.

In the next chapter we shall examine in some detail the language of patronage — the concepts and phrases currently used to describe the practices and policies of contemporary patronage. For the moment, however, we shall take three statements about the Arts Council of Great Britain and State patronage of the arts which, while being made in the twentieth century, clearly convey some of the continuity between nineteenth century arguments for State involvement in art, and the practices of the twentieth century.

In April 1967 Lord Goodman, then Chairman of the Arts Council of Great Britain, took part in a debate in the House of Lords. An extract from his speech was subsequently reproduced in the Arts Council's twenty-second annual report, published in 1967:

> I believe that there is a crucial state in the country at this moment.
> I believe that young people lack values, lack certainties, lack
> guidance; that they need something to turn to; and need it more
> desperately than they have needed it at any time in our history —
> certainly at any time which I can recollect. I do not say that the
> Arts will furnish a total solution, but I believe that the Arts will
> furnish some solution. I believe that once young people are
> captured for the Arts they are redeemed from many of the dangers
> which confront them at the moment and which have been
> occupying the attention of the Government in a completely

unprofitable and destructive fashion. I believe that here we
have constructive work to do which can be of inestimable
value. [106]

The arts, and the State's involvement in the arts, is here clearly presented as a
moral good — almost a moral campaign. This is emphasized by the religious
metaphors, both in the use of 'redeemed' and 'captured', and in the repetition
five times of 'I believe'.

While Lord Goodman's approach emphasized the good of the arts in
bringing the young back into the fold, Patrick Gibson, as Chairman of the
Arts Council, made a speech in 1974 which emphasized the good of the arts in
bringing together all classes and groups in society:

If we are to remain a coherent society with common aims and
shared values we must try to create a world in which we are
brought together by shared experiences. The arts can have this
unifying effect, because they can provide bridges between people
of different backgrounds through shared artistic experiences. I
believe this is the fundamental justification for what we are all
trying to do through state patronage of the arts. [107]

While being less overtly religious in tone than Lord Goodman's piece, this
emphasizes the same point. A 'coherent society' is seen as one having 'shared
values', and these are at least in part derived from 'shared experiences'.
Whereas some might argue for religious experience as being the basis of
shared experience and hence shared values, Gibson argues for the arts as
having this effect.

On a more aggressive level the following battle-cry had been sent out in the
Arts Council's twenty-first annual report, published in 1966:

If now battle is joined for the allegiance of young people between
the attractions of facile, slack and ultimately debasing forms of
sub-artistic under-civilised entertainment, and the contrary
attraction of disciplined appreciation and hard, rewarding work,
then we need to know and to enlist all the allies we can get. [108]

In this formulation State patronage of the arts had become a veritable moral
crusade. All the virtues of discipline and hard work were wheeled out against
the moral degeneration of youth — a youth being corrupted by this peculiarly
debasing and under-civilized thing, 'entertainment'.

These three quotations from Arts Council reports are, of course, neither
typical nor untypical of the Arts Council. Statements by Chairmen and
Secretary Generals of the Arts Council are the nearest things we have to
declarations of Arts Council policies, but at the same time it must be
remembered that the Council, as a collective, rarely formulates any broad
principles or articulate policies which can be expressed and debated publicly.
It has not been that sort of organization. Therefore statements and speeches

by Chairmen and Secretary Generals often tend to be their own, personal, homilies on the nature and work of the Arts Council. The statements are heavily coloured by the characters of the individuals holding office.

Nevertheless, given the nature of the organization, statements by Chairmen and Secretary Generals have to be taken as reflecting the tenor of the Council; and, while the three quoted may not be typical of all Chairmen and Secretary Generals, or of the Council, they nevertheless reflect one aspect of the moral stance the Council has taken and they illustrate a way in which the politics of the Council can be expressed in essentially moralistic terms — a morality very similar in form of expression to some of those employed in the nineteenth century as part of the same argument.

## The financing of the State sector

The political and ideological form that State intervention in art takes has, of course, practical consequences in how institutions are organized and financed. The accompanying diagram is a highly simplified and generalized illustration of the financial organization of Government support for art. The complexity of the financial system reflects and expresses the use of buffer or quango organizations as vehicles of patronage; the insistence on a policy of 'response to initiative' rather than clear planning; and the ways in which the divisions of functions between a number of quasi-independent organizations and agencies produces a system within which the possibility of clear planning and thought on the uses and distribution of moneys becomes remote.

The diagram applies to England only — the inclusion of the differences of organization in Scotland and Wales would make the illustration incomprehensible. The financing of education is similarly excluded, as are various agencies such as the Standing Commission on Museums and Galleries, Area Museum Councils and so forth. The diagram is only the most skeletal outline of the system.

The arrows indicate the flow of money. We start with the figure at the bottom (J), representing the tax and ratepayer — the individuals who collectively provide the finance for the system, and for whose benefit it is operated. This individual (J) pays taxes to central Government, and rates to the District and County Councils. Central Government then funds a number of 'independent' national museums (B) under the control of bodies of Trustees appointed by Government. It also funds the Victoria and Albert Museum (C) which is under the direct control of Government through the Department of Education and Science. Central Government also funds the Arts Council of Great Britain (D).

Lower down the left hand side of the diagram is an Arts Centre (H). This represents one of a number of 'independent' establishments in receipt of public money from a variety of sources. Some such Arts Centres combine a visual arts gallery with a cinema, performance area, restaurant/bar facilities, bookshop and so forth.

It has been a principle of arts policy over recent decades that multiple

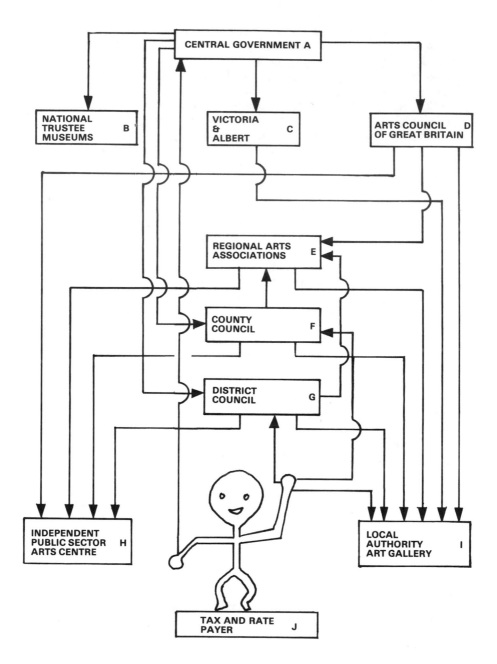

funding of such venues is a 'good thing'. If it is a major venue it may, therefore, receive funding from the Arts Council (D), a Regional Arts Association (E), one or more District Councils (G) and a County Council (F). It may also, for occasional exhibitions or projects, receive occasional sums from the Crafts Council (a Government-funded body not in our diagram) and, for its film work, from the British Film Institute (another Government-funded organization not in our picture).

The Regional Arts Association, meanwhile, which contributes part of the finance of the Arts Centre, in its turn receives a large portion of its finance from the Arts Council (D) — which also finances the Arts Centre. The RAA will also receive funding from the District and County Councils (F and G), who in their turn may be making some small contribution to the financing of the Arts Centre.

The District and County Councils (F and G), of course, receive over half their income not from the rates, but from central Government via the rate support grant.

Assuming for the moment, therefore, that all taxation and rates were raised from the one individual represented on the diagram, and that the single payment of taxation/rates supported the Arts Centre entirely, the money actually arrives at the Arts Centre via eight different routes. First, rates are paid to the District Council which contributes to the Arts Centre. Second, rates are paid to the County Council, which similarly contributes. Third, taxes are paid to central Government which contributes to the finances of the County Council via the rate support grant, the County Council, meanwhile, contributing to the finances of the Arts Centre. Fourth, taxes are paid to central Government which contributes via the rates support grant to the finances of the District Council, which similarly contributes to the finances of the Arts Centre. Fifth, in paying rates to the District Council money is paid to a body which contributes finance to the Regional Arts Association, which in turn helps to finance the Arts Centre. Sixth, in a similar way the rates to the County Council go to the RAA and thence to the Arts Centre. Seventh, in paying taxes to central Government the money goes from there to the Arts Council of Great Britain, and from thence to the Arts Centre. Eighth, in paying taxes to central Government which then go to the Arts Council money is contributed which can then go on to the Regional Arts Association and from thence to the Arts Centre.

The Arts Centre, of course, has to negotiate with only four bodies: the District and County Councils, the RAA and the Arts Council. If the Arts Centre is lucky, it may be that one of these contributes substantially (i.e., is the effective source of finance) while the others provide small but useful additional sums in support of the basic source of finance.

While it is in one sense artificial to hypothesize one individual as tax and ratepayer having money thus divided through eight different routings, the exercise is useful, for it is within the reality to which the model approximates that actual public, political and rational control of public expenditure on art gets lost.

Thus far, however, we have only followed through the financing of an

'independent' Arts Centre. If we now turn to the art galleries directly managed by local authorities we find a different, but similarly confusing picture.

Local authorities are currently empowered to run, manage and own art galleries at either County or District levels. In some parts of the country museums are a District responsibility, in others a County, and in some cases responsibility is shared. The main funding is relatively simple, coming from whichever authority controls the gallery (although bearing in mind also the complexities of the rate support grant as it affects how the tax and ratepayers' money arrives at the institution). However, additional to the main funding administered by the County and/or District authority, the Victoria and Albert Museum (C) administers central Government assistance towards the purchasing of art, this taking the form of a 'matching pound for pound' grant. Further, a local authority museum may apply to either a Regional Arts Association (E) or the Arts Council (D) for assistance towards the cost of a particular exhibition, or to the Arts Council (D) for assistance in the capital costs of building galleries. Meanwhile, while the Arts Council does not assist local authority financed galleries in the purchase of work, the gallery may be able to borrow from the Arts Council works which the Arts Council itself has bought; or may be given on permanent loan, or as a gift, works bought by the Contemporary Arts Society — an independent organization which buys works of art and which is in receipt of regular subsidy from the Arts Council.

Moreover, there are, of course, a few museums where taxpayers may find that they have to pay entry charges once they get there.

This, then, is a simplified version of some of the ways in which some of the money spent on visual arts is routed. The fundamental problems of local government finance and the rate support grant are, of course, not specific to this discussion. However, it is in part the nature of the financial relationship to Government that makes it difficult for some local authorities to develop a museum service as they might like. This, in turn, places more of the burden on other sources of finance such as the RAAs or the Arts Council.

Specific to our discussion is the financial relationship between Government, Arts Council, National Museums, RAAs, independent and local authority galleries, and the grant scheme administered by the Victoria and Albert Museum. The diagram can only sketch out these relationships on a vertical basis. It cannot display what can be called the horizontal variations: the immense variations in local authority expenditure on the visual arts; the immense variations in what the Arts Council spends directly in different parts of the country and in what it contributes to the RAAs; the differing degrees of public access to well-funded art galleries and temporary exhibition venues, and so on.

At one level the system appears, and is, chaotic. After 150 years of the development of local authority and centrally financed art galleries and temporary exhibition venues the degree and quality of provision has all the appearance of a series of isolated, individual acts and initiatives. In public libraries, education, health and social services we can generally expect, and will generally get, at least a minimum of provision in all parts of the country.

With art galleries and temporary exhibition venues this is far from true. Distribution and access is chaotic and unprincipled. But (and this is the point we have been emphasizing) the apparent chaos is not simply the consequence of a lack of thought or of the subject not being taken seriously by central or local government. The distribution of facilities and the organization of finance is precisely the consequence of specific assumptions, arguments and practices — those we have been examining in this book. Central to these is the exclusion of politics (in its narrower sense) from art, for a good and equal distribution of galleries and venues would require political action (would require clear thought, planning, assessment and action at some level). It would also require not the chaos of multiple financing currently operated as a protection of the independence of galleries and art, but clear single financing (from whatever source) given on the basis of clear principles, policies and understandings.

## A Ministry of Culture

When or if a Government Minister is appointed with responsibility for an aspect of economic, social or cultural life, that area of work is made a political issue — using 'political' in one of its narrower senses. The area of work is made political in the sense that it is taken seriously within the conventional structure of political life (Parliament, elections, MPs, Government, manifestos, political debate, etc.) and formal responsibility for that area of life is vested in a 'political' figure.

It does not necessarily follow, within the British system, that having a Minister responsible for an area of work automatically politicizes that area of work, but in the long term this tends to happen. Ministers can tend to be no more than senior administrators or figure-heads *vis-à-vis* their area of Government work, but successful ministers are judged successful by the initiatives they take and the policies they implement. There are structural pressures on ministers to act politically, rather than simply administratively.

In Britain there have been pressures both for and against the appointment of a minister responsible for art and culture — these contrary pressures often coming from the same people. As an example of this we examined in Chapter 2 the arguments of Alexander Beresford Hope, MP, before the 1863 Royal Commission investigation of the Royal Academy. Beresford Hope argued both that 'There should be, in short, a Minister of Arts and Works', and that such a Minister should be kept 'in check by a central regulating body for the various art movements of the country' — this central regulating body to be 'independent' of the Government of the day. Beresford Hope's proposals illustrate a recurrent argument, both wanting and not wanting a ministerial appointment for art.

This ambivalence towards politics and a political appointment is an issue we have already examined. On the one hand, the appointment of a Government Minister symbolizes the importance and status of a particular area of life, and lends the authority of the State to whatever policies or position that

Minister backs. On the other hand it represents a political threat, for it includes the possibility of that Minister using both the authority of the State, and his power-base as an elected representative of the people, against whatever interest groups or classes consider the Minister's area of responsibility to be their special preserve. Hence, of course, the complex set of counter-balancing proposals which Beresford Hope made in 1864.

In 1965 the Labour Government presented to Parliament a White Paper, *A Policy for the Arts — the First Steps*. The Paper, presented to Parliament by the Prime Minister, had been prepared by Jennie Lee, MP, a Parliamentary Secretary to the Minister of Housing and Public Works.

In the White Paper it was noted that Government aid to the arts had grown up 'in response to spasmodic pressures rather than as a result of a coherent plan'.[109] At the local level there was 'no common pattern among Local Authorities' when it came to support for the arts.[110] There was, the White Paper noted, 'ample evidence of the need for a more coherent, generous and imaginative approach to the whole problem'.[111] It was stated that it would 'take time to work out a policy in full detail'[112] but among the objectives established in the paper was the 'need for more systematic planning and a better co-ordination of resources'.[113] The crucial paragraph in the document was number 77, where it was stated that;

> The Government have reviewed their own administrative arrangements. They have reached the conclusion that the time has come for the Government's responsibility for the arts to be centred in a Department other than the Treasury, since public expenditure on the arts has developed to a state when it has already become anomalous for the Treasury to remain the sponsoring Department. These functions are accordingly being transferred to the Secretary of State for Education and Science, who will delegate responsibility to one of the Joint Parliamentary Under-Secretaries of State in his Department.

Three important points emerged from the White Paper. First, an argument for the need for more coherent planning; second, the decision to move funding of the Arts Council from the Treasury to the Department of Education and Science; third, the decision to appoint what was to become known as a 'Minister with special responsibility for the Arts'. Jennie Lee was the first Arts Minister. Initially she was appointed as a Joint Parliamentary Under Secretary within the Department of Education and Science, her position being upgraded in February 1967 to the level of a Minister of State in the Department of Education and Science.

The White Paper maintained and reasserted the independence of the Arts Council from direct Government control, stating that 'The Council will continue to enjoy the same powers as they have exercised hitherto and will in particular retain their full freedom to allocate the grant in aid made available to them.'[114] Eric White, Assistant Secretary to the Arts Council from 1942–71, suggests that this reassurance was included because 'of special

representations made by the Chairman and Secretary General of the Arts Council, when they visited 10 Downing Street in January 1965 and were given an opportunity of discussing the draft of the white paper'.[115]

The sense, however, in which the very appointment of a Minister involves a politicization of the arts is evident, from the first, in the wording of the White Paper. The calls for 'more systematic planning' and a 'better co-ordination of resources' in the context of appointing a Minister illustrate the pressures towards policy making which are inherent in the appointment of a Minister. Eric White stated that:

> There seemed to be a slight risk that the new arrangement might lead to the setting up of a department within the Department to which civil servants would be seconded to advise the Minister on different aspects of arts policy. Indeed, there were moments during the next few years when this 'department' seemed to assume something of the character of a 'shadow' Arts Council Secretariat.[116]

This is, of course, exactly what one would expect, for it is not in the nature of ministerial appointments for Ministers to confine their role to being a benevolent uncle or aunt to other people's offspring.

Eric White, as Assistant Secretary to the Arts Council, was looking at the issue largely from the point of view of the Arts Council. The appointment of a Minister for the Arts involved, in fact, much more than simply a Minister with Governmental responsibility for that which the Arts Council was already doing. The Minister, potentially, related much more broadly to the whole spectrum of Government provision in the arts, crafts, museum and entertainment world. The logic of the appointment was and is for the scope of the Minister's job to be steadily increased so that national policies are devised and implemented over the whole spectrum of artistic, museum and related matters. Thus the logic of the appointment is for the scope of the Minister's work to be steadily enlarged until there exists what, to all intents and purposes, is a Ministry of Culture.

A step in that direction was taken when Lord Eccles was Minister for the Arts, with the establishing of the Crafts Advisory Committee — now the Crafts Council — the scope of the Minister's responsibility being thus extended. The most significant developments, however, came in the first few months of Norman St John Stevas' second term as Arts Minister under the new Conservative administration of 1979. St John Stevas (as Chancellor of the Duchy of Lancaster and Leader of the House as well as Minister for the Arts) took what had hitherto been a junior ministerial appointment within the Department of Education and Science, and established what he termed 'a separate and efficient office of arts and libraries'.[117] He described the establishing of this separate office as 'the first task, on the success of which everything else depends', 'everything else' being an 'arts policy . . . planned to be implemented over a period of five years'.[118]

The establishing of a separate office dealing with the arts, heritage,

museums and libraries was a logical and necessary step given the appointment of a Minister for the Arts. It was also a necessary step if any minister was concerned to bring some order out of the chaos of administration and funding of the arts on a national level. In no sense does the development yet (or, necessarily, ever) involve a significant move away from the quango model of State intervention in the arts. That is not only likely to continue, but one of St John Stevas' first actions as Minister for the Arts was in fact to increase the number of quangos operating in the arts field by introducing legislation to establish the National Heritage Fund. The establishing of the Minister, however, in a separate office is likely to herald a greater coordination and monitoring of the work of the various quangos, as well as of the work of central and local Government. The 'shadow Arts Council', to which Eric White referred, is likely to get stronger, not weaker.

However, while the quango model of State intervention in art is likely to continue, along with all the divisions of functions, responsibilities and powers between different quangos and levels of Government, the appointment of the Minister represents a significant move away from the concealed or disguised politics of the quango model, towards a potentially more open and explicit policy making and political programme at Government level. This change in style and emphasis is stressed in the phrasing St John Stevas used when he said: 'Conservative arts policy is planned to be implemented over a period of five years, not five months.'[119] For all his emphasis elsewhere on the benefits of the 'arm's length' or 'buffer' principle in arts funding, and his maintenance of the quango model for arts finance, such phrasing is that of a politician designing and implementing programmes within the life-span of an elected Government. There is likely, in the future, to be an increasing tension between the aristocratic or gentlemanly style of the quango as an instrument of State policy, and the policies of the Minister; although it is also likely, given the concealed nature of the relationships between Government and quangos (Arts Councils, Regional Arts Associations, the Standing Commission on Museums and Galleries, Crafts Councils, National Museums) that the tensions will often be hidden — that pressure will be applied behind closed doors, rather than through a formal or open political process.

## The national tensions

While the development of an Arts Ministry at Governmental level introduces into State intervention in art a conventional political element hitherto lacking, a lesser, but interesting pressure towards more coherent and open policy-making and planning has come through the development of Arts Councils in Scotland and Wales.

Under the Arts Council of Great Britain's first Charter of 1946 it was stated that:

> 12. (1) The Council shall appoint,
> (a) with the consent of our Secretary of State for Scotland, a Committee for Scotland,

(b) with the consent of Our Minister of Education, a Committee for Wales,
to advise and assist the Council in the promotion of the objects of the Council in Scotland and Wales respectively.

In formal terms, therefore, these 'Committees' in Scotland and Wales had the same status as any other committees of the Arts Council of Great Britain: they existed to 'advise and assist'.

Under the new Charter of 1967, section 8 (1), the clause was rewritten as follows;

> The Council shall, with the approval respectively of Our Secretary of State for Scotland and Our Secretary of State for Wales, appoint committees to be called the Scottish Arts Council and the Welsh Arts Council, to exercise, or advise them on the exercise of, their functions in Scotland and Wales.

Two important changes occurred in the wording of the 1967 Charter. First, there was the formal recognition of the Welsh and Scottish committees as 'Arts Councils'; second, the original Charter's 'advise and assist' was replaced by 'to exercise, or advise them on the exercise of'. In formal terms the relationship between the Scottish and Welsh Councils, and the Arts Council of Great Britain, remained the same, except that the Arts Council of Great Britain was empowered to effectively delegate its work in Scotland and Wales to the new Councils, without necessarily retaining formal control over the two committees.

The Welsh and Scottish Arts Councils are, essentially, the same type of organizations as the Arts Council of Great Britain. The Councils are bodies of Government appointees, 'worthy people with "an interest" in the arts generally'[120] chosen more for their public position than for their knowledge or understanding of particular art forms; the Councils are advised by the same system of advisory committees as in England, and the main work is done, as in England, by a specialist full-time staff who have to negotiate their policies, decisions and relationships to artists and publics through the uneasy relationships between Council and committees. The Welsh and Scottish Arts Councils are, further, characterized by the same adherence to a policy of having no clear policy, responding, rather, to other people's initiatives, as is the case in England.

The important differences between the Scottish and Welsh Arts Councils and their parent body in England are twofold. First, the areas and populations administered are smaller. It is possible, therefore, for the specialist departments to work closer to, and with a greater knowledge and understanding of, their artists and publics than in England. Also, therefore, in smaller countries with smaller populations, the Scottish and Welsh Arts Councils are more vulnerable to criticism and debate. The second and more important difference between the Scottish and Welsh Councils and that in England, however, is the different 'national' context.

There is a strong sense in which the idea of a 'British' national culture (both in the senses of 'art' as culture, and in the wider senses of 'culture' as 'ways of life') is a culture of the English middle, professional and upper classes. More particularly (and especially in the visual arts) it is a culture dominated by a Southern English, essentially London and metropolitan, form of middle class, professional and upper class life. When the word 'national' is used in a British context in relation to art, and is coupled with words such as 'institution', 'standards', 'quality', 'perspective' or 'gallery', we find we tend to be talking of things that are essentially English, and, more specifically, are of particular classes, groups and interests within and around London.

It is in relation to this concept of 'national' that the Regional Arts Associations in England find themselves marginal, and to which they are subordinated. Their weakness derives in part from their inability to establish their own integrity, strength and distinctiveness in terms of a language and culture that is heavily centralized and London-based. Their weakness in terms of the language and culture of England is then reinforced by their inadequate funding.

The populations served by the Scottish and Welsh Arts Councils are equivalent to (and, in the Welsh case, smaller than) some of the populations served by the larger English Regional Arts Associations. The difference in Scotland and Wales is that, set against the 'English – British' sense of national (to which the English regions and, sometimes, Scotland and Wales are subordinated) there exists a counter-acting sense of 'national' as meaning Scottish or Welsh. This is illustrated by an anecdote recounted by Raymond Williams in a talk on *Welsh Culture:*[121]

> A friend from the North of England said to me recently that the Welsh and Scots were lucky to have these available national self-definitions, to help them find their way out of the dominance of English ruling-class minority culture. In the North, he said, we who are English are in the same sense denied; what the world knows as English is not our life and feelings; and yet we don't, like the Welsh or the Scots, have this simple thing, this national difference, to pit against it.

Williams replied to his friend: 'Then you might get through, quicker, to the real differences, the real conflicts'. His friend rejected this, saying: 'To get the energy to do that you need the model'. Williams remained only half-convinced: 'I still don't agree, altogether, but it is how we might look at it.'

Williams' caution was well founded. Within Wales some elements of the Welsh nationalist movement are prone to confuse particular forms of class dominance and economic organization with the 'English', or an idea of 'English dominance'. 'The real differences, the real conflicts' are lost within a rhetoric of 'national' antagonism. At the same time, to get to 'the real differences, the real conflicts', as his friend said, 'you need the model'. The cultural imperialism of the British ruling classes is not articulated in class terms; it is conveyed through moral, cultural and educational arguments. The

political and economic relations of British society are articulated and maintained through a language which while being rooted in, appears separate from, the actual relations of power. To 'get the energy', therefore, to work against 'the model', the difference of national identity can be important. And it is important to understand that in Scotland and Wales there exists a fundamental difference between what outsiders may see as a 'nationalist' identity, and what many within Scotland and Wales may work with and understand in terms of a 'national' identity. In the English language 'national' is a word with reasonably positive (and, at the worst, neutral) overtones, just as 'popular' has fairly neutral and at times positive meanings, whereas 'populist' is generally used in a negative sense, as is 'nationalist'. In terms of the politics of the English language, to be proud of one's national heritage and tradition is both acceptable and laudable; to be a nationalist is suspect.

It is in terms of a 'national' (as opposed to 'nationalist') identity that the Scottish and Welsh Arts Councils are interesting. For, while on the one hand they are constituted according to the same model and in the same way as the Arts Council in England, on the other hand they also have to achieve a certain measure of public success and recognition in terms of their counter-acting 'national' identities; they are compelled, in so far as they are constituted as *Scottish* and *Welsh* Arts Councils, to maintain, reproduce and enhance traditions, practices and directions which, if not different from, can at least be seen as equivalent to, those of the 'British' tradition, as sustained by the Arts Council of Great Britain in England.

Northern Arts, as the richest of the English Regional Arts Associations, has to struggle, in the English context, to maintain and argue for the integrity and value of practices in its own region against the derogatory or negative overtones of being 'regional', 'provincial' and, even, 'parochial'. In Scotland and Wales, in contrast, whatever the tendencies within the Arts Councils towards the sustaining and promoting of a pale imitation of metropolitan standards and fashions, they have also, in terms of the alternative national identities of Scotland and Wales, to justify themselves according to ideas of 'national' strengths and traditions understood as being equivalent to, rather than subordinate to, the English (British) national tradition.

The situation is both complex and ambiguous. It is ambiguous in that both the Welsh and Scottish Arts Councils, while rejecting a 'nationalist' role, accept a 'national' role. In so far as they accept the latter, they have to work against the centralization inherent in the British political, economic and social system; they have to work actively to establish their contrary identities. The existence of the Arts Council of Great Britain, and its equivalent English (British) national bodies, is predicated on an acceptance of the cultural (socio-political) status quo; it sustains and reproduces particular cultural formations. The Scottish and Welsh Arts Councils, in order to justify their existence, have, in part at least, to actively create and support a contrary and at least parallel tradition. In order to do this, a greater degree of explicit thought, policy making, political action and argument, is required than is required in the British 'national' context.

In the Arts Council of Great Britain's annual report published in 1956, *The*

*First Ten Years*, the tendency for provision to be centralized in London was mentioned.

That report was published after a ten-year period during which the Arts Council had closed its regional offices and heavily centralized its operations. The centralization of its work was mentioned in passing, and justified on the grounds that the Arts Council had not created that centralization: the national companies and galleries were already in London. London was the capital city; it was not the Arts Council's fault that that was so.

The Arts Council at the time, as a body lacking a national geographical and social perspective, was adding to, sustaining and enhancing that centralization. In its own eyes it was only following a pre-given pattern. This followed, of course, from its policy of response rather than planning — a policy which led to the strengthening and reproduction of the status quo: a strengthening of the existing social and cultural patterns.

The Welsh and Scottish Arts Councils cannot accept such a situation. As national bodies they cannot abrogate responsibility to the existing social, economic and political forces. They have and had to establish something of a different pattern.

They have not done this strikingly well. They have in fact reproduced, in Cardiff and Edinburgh, something of the same relationships between the capital cities and the rest of the country as exists in England. But at least, within the British contexts, they have provided something of an alternative; in having to work with and in terms of separate 'national' identities, they have had to seek to establish alternative centres to London.

The Scottish and Welsh Arts Councils are constrained by the same aristocratic, privatized modes of operation and organization as in England: they are constrained by being organized as a paternalistic form of organization. But they have, at the same time, established practices and identities in a way that has not been true in the English regions; and they provide models for the English regions of what decentralization and devolution of power from the national to the regional level could mean and involve.

The establishment of a Minister for the Arts and an Office of Arts and Libraries indicates, at the national British level, one direction away from the informal and aristocratic mode of concealed State control of the arts. At another level, the modicum of success of the Scottish and Welsh Arts Councils in establishing successful practices on what, in British terms, is a regional level, indicates an alternative route away from the informal and heavy centralism of the existing system.

Moreover, while the strengthening of the role of the Minister for the Arts is likely to reinforce the worst (most centralist) aspects of a 'national' British culture, the strengthening of regional bodies, on the same pattern as the Welsh and Scottish Arts Councils, could lead to a strengthening of a more multifaceted view of art and culture.

The Welsh and Scottish Arts Councils are by no means ideal models, but their separation, as distinct 'national' agencies, compels a degree of political thought (policy making, planning, and identification with a 'constituency')

untypical of the English national bodies, and unusual and difficult in the English regional bodies. There is a structural pressure towards politics and policy making in the Welsh and Scottish contexts; there is a structural pressure against it in the English context.

# The reification of quality

Contemporary State intervention in the visual arts can be understood as operating on three fronts: the first is the provision of museums of art dealing with the art of the past; the second is the broad involvement in contemporary visual culture via exhibitions, grants, awards, commissions, subsidy and purchases, as practised by arts councils, regional arts associations, and museums collecting art by living artists or mounting temporary exhibitions of the work of living artists; the third is the provision of education and training in art through both general education and specialist art schools.

In this book we have traced something of the development of all three kinds of involvement in art, but, more particularly, we have examined the forms and structures of State organization and intervention, and the policies and assumptions underlying the involvement of the State in art.

We have noted that, with the exception of the period in the third quarter of the nineteenth century when Henry Cole was in charge of developments at the Department of Science and Art, the growth of State involvement in art appears to have been largely *ad hoc*, institutions and policies accruing and accumulating without much overall or long-term planning or thought. However, we have also noted that underlying the superficial disorganization has been a long-term consistency and coherence at the level of the forms and relations of State intervention in art, and the ideologies and philosophies that are part of these forms and relations.

At one level it could be said that the involvement of the State in art over the past two centuries has served to reinforce, reproduce and amplify the status quo. Public museums of art grew from and took on the style of private, aristocratic collections; and incipient 'professionalism' among artists was encouraged and sustained via the Royal Academy, the development of 'public' art schools and the status given to art through museums of art. The post Second World War development of arts councils and regional arts associations has served to reinforce and strengthen the existing social, cultural and geographical patterns, and, just as the major institutions of British capitalism and British political life are heavily concentrated in London, so State intervention in art has tended to reinforce that same imbalance in the visual arts. The major public collections of art, the most prestigious art schools, the most prestigious and extensive temporary exhibition venues, and

the largest part of Arts Council patronage, are all centred in London.

But to say simply that the State has tended to 'reinforce, reproduce and amplify' the status quo would be misleading, for that would be to disguise the extent to which the effects of State involvement to the visual arts have been active. The status and influence given in the Royal Academy by Royal and Governmental patronage rendered that institution the most actively influential and important art institution in late nineteenth century Britain. Both Sir Charles Eastlake and Sir Edward Poynter held appointments as Presidents of the Royal Academy and Directors of the National Gallery. Such influence and power was *active*. The Arts Council of Great Britain, as effective successor to the national power and influence of the nineteenth century Royal Academy, similarly wields an *active* influence and power. For the reinforcing and reproduction of the status quo is as active an intervention in art as any more overtly and obviously energetic an alternative.

'Status quo' is, of course, too broad and generalized a term. It begs the question of 'whose status quo?' For an aspect of the *active* intervention of the State in art has been its support of particular cultural definitions and contexts. We have referred, for example, to the 'aristocratic' style of the arts councils and regional arts associations, and to the incorporation of professional groups into these. The Arts Council of Great Britain, which consistently presents itself as responding rather than initiating, was and is, in both its constitution and practices, selective in its responses. In its constitution it represents a selective response and initiative, this being laid down in its charter — the document which expresses the government's decision to involve itself in the arts via an 'independent' semi-private institution established under the Crown: and the practices of the Council have, of course, been largely shaped by that constitution. The Arts Council's Charter is not simply a legal document defining and establishing the institution; it is a statement of cultural policy — perhaps the most important and least read document of cultural policy to have been published in the last fifty years. For the Charter, in defining a particular kind of State intervention in art, also defines a particular set of cultural relations. The Charter was a response to, an expression of, and an invitation to a particular kind of patronage of art and philosophy of art. It invited and gave power to a cross between a private aristocratic and benevolent style, and a patronage of the culture of particular professional groups by those professional groups.

## The constitution of a culture

We can define the 'culture' of art as being the traditions, meanings, understandings and contexts of that art which at any one time is being produced and used. That 'culture' is the product of a complex set of interactions. Artists make art, but the culture is the product of an interaction between artists, their work, patrons, buyers, commissioners, educators, historians and critics. Art and artists exist only within and as part of this set of interactions, and what constitutes the culture of art is the product of decisions

97

and judgements at many levels.

In terms of this understanding of a culture, institutions established and funded by the State cannot be passive — or at least, in so far as spokesmen for State institutions represent these institutions as simply responding to or reflecting an existing and separate culture, they misrepresent and misunderstand the role of such institutions within and as part of the culture. Just as the collecting and exhibiting policies of the Tate Gallery shape understandings of what constitutes current art (and set the conditions for arguments over what constitutes significant art) so the decisions of arts councils and regional arts associations shape and define aspects of what shall constitute the culture of art.

The culture of art has traditionally been the product of a multiplicity of individual aesthetic responses and choices, although, of course, the influence of any one response or choice on the culture of art has varied in proportion to the influence of the individual as an individual or as a member of an institution. Thus the private wealthy collector has more influence or effect than the private collector with little money; Ruskin, as an individual critic who established a wide reputation, exercised great influence as an individual; and Sir Charles Eastlake, as Director of the National Gallery, exercised great influence on the culture of art through that institution.

While, however, the aesthetic responses and choices that effectively constitute and shape the culture of art are essentially individual, and thus *subjective* matters, the history of art has been one of normative assertions argued for as if *objective*. Culture is and has been shaped by and part of the class structure of society in that the dominant classes and groups are also those that control the means of education and communication: and the dominant classes and groups tend to elevate *their* culture to the status of *the* culture — arguing, of course, for the objectivity of their understandings.

This prescriptive approach to the culture of art, while sustaining and allowing for interesting work, permits this only on and within its own terms. In the past these terms have covered the style and content of works of art, but, more importantly, they are to do with the values and meanings ascribed to art, the social contexts within which art is allowed or encouraged to develop and be seen, and the social, cultural and educational requirements stipulated as being necessary for an appreciation of or involvement in the culture of art.

In the post Second World War period State intervention in art via the Arts Council of Great Britain has tended to be prescriptive in this latter sense, the prescriptions being expressed in terms of the Arts Council's promotion of and adherence to the concepts of 'quality' and 'standards'. These have been the two key concepts in Arts Council policy; they have been argued for as objectively knowable — but knowable only to those who have had the necessary education and experience.

## Quality and standards

In the Arts Council's annual report for 1972–3 it is stated that, 'The first object in our Royal Charter covers quality and standards'.[122] The reference is

to Paragraph 3, Section (a) of the Charter, where the first of the three objects of the Council is defined as being: 'to develop and improve the knowledge, understanding and practice of the arts'. The clause in something of a catch-all phrase, open to many and differing interpretations. Most interpretations of the literal meaning of the object would go considerably further than seeing it simply as covering 'quality' and 'standards'. The interpretation given to the clause in the Arts Council's 1972 – 3 report, however, both illustrates and reflects a long-standing Arts Council interpretation of its duties.

The practical meaning of this approach is that Council policies are based on a multiplicity of individual aesthetic responses and judgements made by those individuals who comprise the Council, panels, committees and staff of the Arts Council. These judgements, which essentially are the subjective judgements of individuals, are presented publicly as group or committee judgements, the validity of such judgements being argued for according to objective notions of 'quality' and 'standards' which the individuals who are members of the council and committees of the arts councils are said to understand.

It may be that we all have notions of what constitutes good, bad, interesting, worthless and worthwhile art; we may all, further, have an understanding of what constitutes quality. In so far as we do, however, these are matters for debate and discussion. If Arts Council spokesmen argue for the existence of 'objective' rules of 'quality' and 'standards', and if these rules are operated in private (within committees whose proceedings are confidential), then a central element in an open and active public culture of art is being removed from the public arena. A view of art is being prescribed by an unpublic authority for an audience who is assumed to be a passive recipient, rather than an active participant.

Roy Shaw, Secretary General of the Arts Council, has expressed clearly in his writings both in the Council's annual reports and elsewhere, the Council's long-standing approach to the issues of 'quality' and 'standards'. Thus in writing about what he terms the 'populist' attitude to the arts, he has referred to the dangers he sees as following from an attitude which: 'Questions the validity of all objective standards of taste. . . . The danger in the populist view of culture is that anything goes and the very idea of quality becomes suspect as an authoritarian or elitist one.'[123] The phrasing here is similar to that used by Shaw in the Arts Council's annual report for 1975 – 6, where, referring to a conference he had attended at Oslo, he reported that:

> I found at Oslo that many of my fellow experts from Europe cared too little for what they sometimes disparagingly refer to as the 'heritage concept of culture'. I shall never forget having to fight single-handed to persuade a group of experts that it was essential to ensure the *quality* of the arts we foster. 'Quality', they unanimously assured me, was a purely subjective concept, far too vague to use in cultural policy. A few people in Britain say the same, advocating 'relevance' as an alternative to qualitative standards. If not resisted, such thinking could gradually subvert any cultural policy and produce a situation where 'anything goes'.[124]

In both these quotations he posits only two options: on the one hand current Arts Council practice with the Council, as public patron, essentially acting as a public arbiter of taste; and on the other hand a situation where, without the careful monitoring of quality, values disintegrate and 'anything goes'.

In the Arts Council's annual report for 1978–9 Shaw was more cautious, recognizing that judgements on quality could vary widely. The Arts Council's procedures were justified, however, on the grounds that:

> It is possible for people with long experience and deep knowledge of a particular art form to rise above the simple emotional dogmatism of the philistine who says 'My five year-old does better pictures than Picasso'. The belief that all judgements on the arts are *wholly* subjective, that no opinion is better than another and that 'nothing is good or bad but thinking makes it so', makes nonsense of the Arts Council's assessment procedures — and of much else besides. [125]

The people 'with long experience and deep knowledge' referred to are, of course, those who have achieved highly in the educational system. In Shaw's view a prerequisite for the appreciation of art is a good education, a point he made clear in a lecture in saying:

> In fact the majority of people are really forced to settle for popular culture and have no opportunity to choose high culture because they lack the educational equipment which alone would open the door to high culture for them. [126]

In a tautological sense this is certainly true. If the culture espoused by an educational élite also requires a formal education to be understood and is also defined as the highest and best culture, then that culture is and will only be a culture of that élite. It is in these terms that it can be said that nonsense is made of the Arts Council's assessment procedures, for if the culture promoted is that of an élite and for an élite, no effort on the Arts Council's part as a public authority will ever make that culture 'accessible' to the public throughout Great Britain — unless that public also becomes part of the élite. Such a transformation is not in the Arts Council's power to effect.

## Culture and 'ordinary life'

Historically it has been and is a characteristic of that defined as 'high culture' that it has only a minority appeal or audience — that audience being an élite audience. That which is popular or widely understood and used is usually excluded from the definition of 'high culture'. High culture is, of course, defined by the élite as that which is 'best', most 'significant' and of the highest 'quality' and 'standards'. The culture of the élite is universalized as the culture of the society; the failure of the mass of society to appreciate or be

involved in that culture is accounted for by reference to lack of education, manners or intelligence.

The exclusion of the mass of society from high culture is usually partly social, and partly to do with the iconography, content or meanings inherent in the work of art. The social exclusion is usually the most powerful. The style and feel and atmosphere of an art gallery, along with the tones of voice, forms of dress and ways of behaving of a gallery audience, can be more excluding and incomprehensible to someone not brought up to visit galleries than the work on the wall.

The work itself, however, may also be excluding. A significant part of the work promoted by the Arts Council over the last twenty years has, within Britain, been the product of a community of artists based in and centred around art schools. This community, steeped in a particular history of art, has sustained an art the comprehension of which requires an extensive knowledge of that particular history of art. Some of the art has been referential only to other art; some of it has been of the kind that can be called 'artists' art' — an art produced essentially for other artists as the audience.

Within the terms of its own tradition and culture much of such art may be work of 'quality' and 'standards'. Some of it, however, is also self-evidently a culture of and appropriate to a particular social group. It is an art that speaks of and is concerned with the lives and experiences of that group. It can and should be understood within that context.

It is certainly true that a lack of an appropriate education is a factor in a widespread lack of public sympathy for certain kinds of contemporary art. But the education required for that art to be centrally important to most people's lives would not be simply a general higher education; it would be an education that initiated most people into that social group and form of life — that led them to a position where that art spoke of *their* lives.

Art must be understood in its particularity. To present that which is rooted in particular forms of life and experience within the universalistic terms of 'best', of the highest 'quality' and 'standards' is to convict of visual illiteracy the majority who cannot respond with sympathy or enthusiasm to *that* form of art. This arrogance is well understood. For, in so far as there exists a widespread resentment against what is loosely understood to be 'modern art', the resentment is a consequence not of the art itself but of the claims made for it. There are many areas of life which are incomprehensible to all but the specialist or connoisseur; these rarely elicit resentment. The resentment follows from the claim, implicit or explicit, that to fail to appreciate something is to be uneducated, uncultured and lacking in something essential to a full life.

Those who are, or feel, excluded from that which is defined as high culture generally do not feel excluded from cinema or television. These media employ highly sophisticated visual systems. Television and cinema demand of the general population as complex an ability to decode and understand as any other cultural form; and this ability to 'read' the medium is as necessary for its most trivial productions as for its best. Even the most mundane of soap operas can employ forms of editing, cutting, mixing and shifts of emphasis, focus

101

and angle, that require highly sophisticated visual decoding.

Such decoding is undertaken as a matter of course by the majority of the population. This ability to decode is not, of course, natural or inborn. It is learned, as with most things. But it is acquired by those who 'lack the educational equipment which alone would open the door to high culture for them' in precisely the same way as it is learned by those who acquire the equipment necessary for entering the cultural door.

This widespread ability to decode the sophisticated media of television and cinema suggests that education, certainly in the formal sense, is not in itself the barrier to an appreciation of art in the high cultural sense. If a complex capacity to decode the visual imagery of television and cinema (not to speak of their use of sound, speech and music and dramatic conventions) can be acquired without an extended formal education, it suggests that the same could be true of the culture of art: or, at least, that that which is exclusive in the culture of art is not necessarily a complexity inherent in the media.

## An open and active culture

John Maynard Keynes, as first Chairman of the Arts Council, said: 'Do not think of the Arts Council as a schoolmaster. Your enjoyment will be our first aim.'[127] However, in that the Arts Council has seen its prime function as being to raise and monitor the standards and quality of the art which it promotes and allows, its stance and style has become essentially schoolmaster-ish. The Council has been described as 'paternalistic', and this is most strongly evident in its activities as an arbiter of taste.

'Standards' and 'quality', as the key concepts in the Council's justification of its role, are powerful words. They appeal to that which appears to be obvious, and their usage invites the restrictive thinking on cultural policy which poses only two options: on the one hand the Council as an arbiter of taste, and on the other hand a situation where 'anything goes'.

The commonest usage of the word 'standards' in Arts Council literature is in the form that Raymond Williams calls a 'plural singular — in which the plural form covers a singular reference'.[128] With the plural singular;

> The reference is essentially CONSENSUAL . . . ('we all know what real standards are') or, with a certain deliberate vagueness, suasive ('anyone who is concerned with standards will agree'). It is often impossible, in these uses, to disagree with some assertion of standards without appearing to disagree with the very idea of quality: this is where the plural singular most powerfully operates.[129]

'Quality' is in many ways an equally difficult word. As with 'standards', it is a word that demands agreement ('Who is against quality?'). As with 'standards', it is a word that appears to be specific (that appears to refer to something that we all *know*) when in fact it often serves to displace real debate

about particular works, particular qualit*ies*, and particular responses.

We could take Williams' designation of 'standards' as a 'plural singular' (and as problematic in that form), and refer to 'quality' as a singular plural — its difficulties stemming from its usage in that form. For 'quality', in the singular, appears to refer to a single known characteristic of art — some specific characteristic of work which we can all understand and measure. If we talk of 'qualit*ies*', however, as a real plural, we are talking of something very different. 'Qualit*ies*' is a word that invites discussion and debate; to talk of the 'qualit*ies*' of a work invites a more specific discussion about particular aspects of particular works. 'Quality', in the singular, effects a closure, as does 'standards'.

'Quality' and 'standards', then, as two of the key concepts in Arts Council policy, are symptomatic of a closed culture. They effect a closure on a process that needs to be open; they demand consensus in a culture and society that is varied and diverse. They appeal to unargued implicit assumptions about the nature of culture and the nature of art. They universalize what needs to be argued from the particular.

The qualit*ies* of works of art do, of course, matter. They are central to the experience of works of art. It is the qualit*ies* of works that we respond to, that make the experience worth while. Qualit*ies*, however, are many and various. They cannot be predetermined or prejudged. In an active, open and developing culture of art the 'qualities' (meanings, styles, iconography, contexts, intentions, etc.) of works of art are the central subject of response, experience and argument. In an open, active and developing culture of art, moreover, the argument is between the artist, the artist's work, and the artist's public. An active and open culture grows and develops from that interaction.

# The need for a Political Approach

A central feature of State involvement in the visual arts in Britain is what I described in Chapter 8 as an 'erasure of politics'. The form of State organization that we today know as the quango; the form of organization that we know as the corporate State; the practice of powers being constitutionally separated between the Crown, the House of Lords, the House of Commons and various levels of local government and regional administration: all these contribute towards, or provide the conditions for, the systematic displacement of overt politics from the exercise of State power and authority. Overt politics is displaced by a cultural consensualism which, while being in fact political, is experienced ambiguously but powerfully as a kind of informal consensual benevolence.

The forms of State intervention in art that we have examined can appear and be experienced as disorganized, flexible, informal, friendly and, in the quaint sense, very 'English'. Or, to use Maynard Keynes' phrasing 'half baked'.[130] Yet the combination of these particular kinds of State organization with the ideological and moral force of the cultural is a most powerful and firm alliance. In questioning current State policy towards the visual arts the individual can seem (and feel) to be questioning some of the fundamental values of our society. Thus we cited earlier Raymond Williams' account of a debate in the Arts Council where his questioning of Arts Council organization led to him being told that he did not understand 'participatory democracy'. Similarly we have seen that to engage in debate concerning the administrative and cultural policies of arts councils and regional arts associations can lead to the accusation that one is rejecting the ideals of 'quality' and 'standards' — in other words, one is culturally a philistine.

The terms and conditions of such debate are set by and are part of the relations and forms of State organization we have been examining; relations and forms which are, in certain real senses, informal, open and flexible. The strengths, virtues, problems and difficulties of 'the British system' follow from the same relations and forms. As a loose alliance of the aristocratic and the professional with the ideal of 'public service', the system is, within these terms, open and informal. Yet it is in precisely the same senses that it is closed and formalized, for it allows of only certain kinds of individualized and informal openness. A social and cultural closure is effected against those who

are not of the loose social groupings who participate in and are part of the openness and informality.

For those who believe in the possibility of, and the need for, a more open and active culture of and for the visual arts, the challenge to this closure has to be and can only be political. Not political in a 'party political' sense, nor, necessarily, political in the sense of asserting the political nature or qualities of works of art. Rather, it must be political in the most conventional of senses. The State is a political entity. The exercise of State power is a political process. The intervention of the State in art is political. The exercise of State power in support of the visual arts (or, rather, *in support of particular understandings* of the visual arts) has to be understood in political terms.

To understand State policy towards the visual arts in political terms is to understand actions and decisions in terms of choices, possibilities, objectives, policies and consequences. If State policy towards the visual arts is understood in political terms, it is seen that the development of that policy has not been simply a series of inevitable and sensible *ad hoc* decisions made by cultured men and women according to purely 'cultural' or aesthetic criteria. There is a politics to decision making, a politics in the exercise of power, and a politics to the notion of cultural or aesthetic criteria. There is a politics as to which people should be and are empowered to make what decisions, a politics as to who is funded, and where and why. And there is a politics concerning what kinds of arguments and assumptions and philosophies receive what kinds of support, and from whom.

Political thinking about political questions invites and implies consideration of contexts and consequences; it invites an open debate about objectives and policies; and it invites the translation of implicit policy that is the consequence of an accumulation of *ad hoc* and individualized decisions into an explicit policy within which frameworks, assumptions and objectives are clearly articulated and argued.

State policy towards the visual arts has been characterized by a conflation and confusion of the aesthetic, the political and the administrative. To understand State policy politically is to separate these elements.

The experience of a particular exhibition or work of art is an aesthetic experience. The decision, however, to fund the gallery within which the exhibition takes place; the decision as to how to organize the distribution and funding of galleries; the decision as to whether and where to fund fully equipped and staffed galleries — or to use money in other ways; the decisions as to whether to fund and whether to tour what kinds of exhibitions and for what kinds of publics; all these kinds of decisions should involve political thinking, for in the public sector such 'public' matters are political decisions.

If that which is political in State involvement in art were to be thought through clearly and articulated as political, the system would be, in a more real sense, open and accessible. The closures effected by consensualism would be replaced by a debate which could be open and public. Decisions and experiences which are genuinely aesthetic could be separated from those which are administrative and those which are political. The different kinds of decisions could be defended and argued for in their own terms.

Earlier I quoted from John Maynard Keynes, broadcasting in 1945 on *The Arts Council — its Policies and Hopes*, saying:

> Everyone, I fancy, recognises that the work of the artist in all its aspects is, of its nature, individual and free, undisciplined, unregimented, uncontrolled. The artist walks where the breath of the spirit blows him. He cannot be told his direction; he does not know it himself.

Such romantic (and in some ways very insulting) descriptions of a particular kind of artist, a particular approach to being an artist, and a particular understanding of art, have underpinned and been used as arguments for the anti-political consensualism and individualism which has characterized State policy towards the visual arts. It is implied that because artists are 'undisciplined, unregimented, uncontrolled' and, crucially, not knowing their own 'direction', State policy (if it is to avoid a damaging and dangerous control of the visual arts) must be similarly organized.

The State, as a 'public' collective, is not and cannot be the same as an individual. Individuals can exercise tastes as they wish. They can respond to the artist informally and openly. It will not be thought strange if the individual's taste is erratic and highly personalized, or if he or she strongly favours one particular kind of art or one particular artist. The State, in the way arts councils and regional arts associations distribute money, and in the way museums of art organize and direct their collections, and in the way schools of art understand and conduct their teaching, may seek to behave like an individual 'writ large'. They may seek to behave as if there is an unproblematic continuity and similarity between the behaviour of individuals as patrons, teachers and collectors, and the behaviour of public authorities. But there is no such continuity and similarity. The nature of power within a State collective is of a different kind, and therefore the choices, arguments and decisions made by the State organization carry different meanings and have different consequences to those made by individuals.

The initiatives, experiences, tastes and understandings of those who work for or with State organizations will and should affect and be part of those organizations. But such individual initiatives, experiences, tastes and understandings in a public authority need to be translated into policies, arguments, programmes and objectives which are not only appropriate to the public collective role of a public authority, but are also shaped by argument, debate and criticism which is public.

Part of such political thinking must be the development of an awareness and questioning of the fundamental reasons for the existence of various kinds of public institutions. Museums of art, for example, have been a feature of the art scene in this country for over 150 years. That is long enough for them to have become an accepted and 'natural' part of our visual culture. We cannot imagine an 'advanced' or civilized society which does not recognize the importance and value of the visual arts through constructing temples to their past and present. From time to time the collecting policies of this or that

museum of art are questioned, but rarely are the full implications of having such public museums and public collections at all held up for examination.[131]

As we have noted, the modern art museum is a development in the public sector of the wealthy individual's private collection. That which the wealthy owned (and own) privately is made available as a publicly owned and directed institution. The private palace is made a public facility.

Such a translation of an aristocratic and palatial style and practice into a public institution may or may not be the most appropriate way in which a democratic society can and should respond to art. Whatever the case, it needs to be argued, and greater account needs to be taken of the differences in kind between a major private collection (which will generally relate to the tastes and experiences of an individual or family, and be used and experienced as part of their domestic environment) and the possible functions of and reasons for a public collection.

## Some reasons for State intervention

There are and have been many arguments and reasons for State intervention in the visual arts. These have varied, however, according to people's political positions, their view of the kind of society we have, their view of the kind of society they would like to see, and their view of what is important in the visual arts.

In the nineteenth century one argument for State intervention in art was economic. In order to sustain and develop Britain's commercial and industrial competitiveness the qualities of design needed improving, and the 'taste' of the general population needed raising; hence, in part, art schools and museums of art. Such arguments still carry weight — thus the Design Council, and the continued funding of design courses within art education. Meanwhile, from time to time, Arts Council personnel give as one justification for Government expenditure on the arts the quantities of foreign exchange earned from tourists attracted to Britain on account of its cultural wealth.

Moral arguments have always been used in support of State intervention in culture. Culture is seen as a civilizing influence which will improve the population — make them better and more responsible people. Such arguments, while common in the nineteenth century, have also been used regularly in the twentieth century, as we noted in Chapter 9.

National prestige and the needs of international diplomacy are important factors behind certain kinds of State support for art. The National Gallery, Tate Gallery, Hayward Gallery and other similar major institutions symbolize and represent the cultural (and political) power and importance of the nation. Meanwhile cultural exchanges (the lending and mounting of exhibitions abroad, as well as foreign tours by major performing companies) are used between friendly nations as expressions of their continued friendship, and between less friendly nations as part of the softening up process for, and as part of the cementing of, the hard politics of international

economic relations and military bargaining. The cancellation of a sporting or cultural event indicates the heightening of cold war tension; and the creation of new or resumption of old cultural (or sporting) links is the signal for a lessening of tension, or the prelude to new economic or military deals.

Also an important general reason behind the growth of State support for art has been the increasing power and influence of the professional classes. The interests and lives of the educated and 'concerned' professional classes have been increasingly served and supported by State power both through legislation and through the establishing of official bodies. Support for art is one aspect of this.

All these are and have been arguments, factors and reasons behind the growth of State intervention in art. They have underpinned the growth of State intervention in art over the past two hundred years. In themselves, however, they have little necessary connection with what State support for and intervention in art could be in a more open and democratic society.

## The social democratic argument

The argument for State intervention in art in a social democratic society is complex, but must differ from the arguments, reasons and factors mentioned thus far in that it starts from the assertion of general public rights and opportunities.

The importance of the visual arts is argued for on the grounds that the visual making, representation, elaboration and understanding of our lives and experiences is something that concerns everybody. Just as we make and understand and communicate our lives and experiences through the written and spoken language, so, it is argued, we should all have access to, be part of, and be involved in the visual making, symbolization, understanding and communication of our individual and collective lives and experiences.

We live in an unequal society. A few have great wealth, many have a reasonable day to day standard of living, and a sizeable minority live in a state of official poverty. Access to leisure, education, transport, work satisfaction, good housing, financial security, etc., is unequally distributed throughout the population.

In such a society, the argument runs, an important function of the State vis-à-vis the visual arts is to correct the imbalances in opportunity, wealth and power through supporting and encouraging a more open and democratic use of and involvement in art. This argument for State intervention in art is, therefore, very similar to the arguments made for State involvement in health and education. These are general 'rights' irrespective of wealth, age, income, sex, colour or class.

The argument is a powerful one — although in the abbreviated form in which I have presented it all kinds of questions and assumptions are left open. Thus, for example, one would have to ask what kind of visual culture (or whose visual culture?) is supported, and in what ways opportunity, involvement or access are increased or made more open.

As we noted in Chapter 7, the Charter of the Arts Council of Great Britain includes, as the organization's second 'object', that it should: 'Increase the accessibility of the arts to the public throughout Great Britain'. This clause is founded within the social democratic argument outlined above. It is an ambiguous clause, however, for it also relates to (or can be seen as overlapping with) the 'moral' arguments noted earlier: and it further allows for the kind of State organization that relates principally to the powers and interests of the professional classes. It relates to these two latter, because 'access' is a difficult word. Access can mean simply allowing people entry to the inner sanctum of art — an entry that will lead to their becoming better and more civilized people. Access can mean no more than that that which the professional classes find interesting and important should be made, in an unaltered form, available to the rest of the population. But access can also be taken to imply, in a more fully democratic sense, a more general involvement in the making and receiving of a pluralistic culture by a variety of groups and classes.

The second object of the Charter, however, is at least an invitation to political thinking for it demands consideration of the distribution of resources (as in *'throughout* Great Britain'); it demands consideration of what 'access' means in both geographical *and* social terms; and it requires thought concerning access to what.

The visual arts have traditionally and historically reflected the interests and tastes of small and powerful sections of society. These classes have tended to universalize *their* tastes, experiences and culture as being *the* culture of *the* nation. State policy thus far (over the past two-hundred and more years) has tended to reinforce and support such universalizations of the interests and experiences of particular groups and classes, adding, to the category of the powerful and the influential, the newer professional classes.

A more open (and politically aware) use of State power would recognize the diversity of interests, experiences and life-styles of a socially and culturally mixed society. It would do that, moreover, without consigning the experiences and cultures of various minorities to the cultural dustbins of the 'amateur' and the 'community' arts. Community arts, in itself, can be a positive thing. Its patronage by arts councils, however, has too often been used as a defensive gesture to justify their lack of serious support of and response to the lives and experiences of the majority of the population. 'Real' culture is distinguished from 'amateur' and 'community' culture, which is seen as a second best thing to give 'the rest'. Ethnic minorities, women, children, the poor, the elderly and the sick are offered 'fun culture', while the remainder of the population (which from that list appears to be largely white, middle class and male) partakes in serious culture.

Of recent years there has been a noticeable move towards a greater political awareness of questions, issues and policies in the art departments of, among others, the Welsh and Scottish arts councils, and the South West and Northern Arts Associations. Policies and programmes have been devised which seek to lend support to a greater variety of artists and craftsmen, in interaction with a wider spectrum of the public. They have begun, in other words, to move away from a position of 'providing' a culture (a culture which

they, therefore, control) to a position where they encourage and develop a more open and uncontrolled series of interactions between artists and publics.

In these cases, however, the impetus towards change (and towards more positive political thinking) has come more from the officers of the organizations than from the artists and publics they serve. It is to be hoped, however, that these developments within the organizations (dependent, as they currently are, on the convictions and understandings of a few isolated individuals) can and will be taken up by those outside the organizations, leading to and cementing a more positive partnership in taking matters forward.

It should not be thought, however, that the need for political questioning and argument is specific to the arts councils and regional arts associations. It must include the distribution and reasons for museums of art, and their collecting policies. That which they collect, and why, has a critical bearing on how our visual culture is understood. It must also include the Crafts Council which, as its income and influence grow, is increasingly coming to follow the kinds of procedures and policies that have been pursued by the Art Department of the Arts Council of Great Britain.

Art education, which for so long developed separately from the rest of education, is today treated as simply a part of general secondary and higher education. Its purposes and effects are, therefore, generally discussed only in 'educational' terms, and as part and parcel of general educational debates. The relationship between art schools and the general visual culture; between art schools and industrial design; between art schools and the support of working artists; and between art schools and the practice of the visual arts in the general population, are questions too often subordinated to purely educational debates. Educational debates are too often confined to questions of individual child and student development, the internal structuring of courses and the nature of qualifications.

The State's support for art education is a major, if not the major, part of the State's support for the visual arts. Any political questioning and understanding of the State's involvement in the visual arts must, therefore, include a questioning and understanding of the current and possible role of art schools and also of art education in secondary schools. [132]

I have noted that one of the ways in which State power is maintained and reproduced in its present form is through the separation of powers and functions. I have concentrated on the separation of powers between different aspects of State Authority as in the separation between Crown, Parliament, local authorities, national quangos, local or regional quangos, and so forth. But equally important is the separation of functions and questions that flows from this. Thus one question is compartmentalized as 'educational'; another as the concern of the 'Crafts Council'; another as to do with a 'national museum' and a fourth as to do with a 'regional' or 'local' museum. Similarly questions concerning the 'professional' arts are from time to time said to concern the arts councils, while questions to do with the 'amateur' or 'community' arts are said to concern the regional arts associations or local authorities. Thus divisions in functions and organizations come to reproduce

and justify and support basic philosophical and conceptual distinctions — distinctions which in themselves may need questioning.

A political approach to and understanding of the implications and use of State power in the visual arts, therefore, needs to reject or question the necessary logic of the kinds of separations of powers we have. They may make sense, but then again they may not. In the nineteenth century, when Henry Cole was at his most powerful, the South Kensington Museums, what is now the Royal College of Art, the local colleges of art, national touring exhibitions, and a vigorous campaign for the establishing of local museums were all under a unified control. That kind of coherence in the *development* of State policy is worth remembering.

Political thinking and questioning can mean and imply many things. But centrally, it involves an attempt to re-understand and re-direct public, collective State power and authority towards publicly defined and argued for goals and objectives. It involves questioning and seeking to understand the most appropriate roles for State intervention, and the most positive and productive relationship between the exercise of State power, and the support of a varied, lively and creative set of interactions between different kinds of publics and different kinds of artists.

Political thinking must involve, importantly, an awareness and acknowledgement on the part of official bodies that they *are* part of the State. In other words the privatization of public authority, and the interlinked denial of political questions and debate, must be rejected. It needs to be understood that State intervention as such need not damage or curtail artistic freedom as currently understood.

I cannot say what this would lead to, except that the purpose of a more open and clearly articulated and debated set of policies and practices is that they should support, and be more appropriate to, a more varied, open and democratic society. This does not, of course, necessarily follow. Clearer and more open political thinking and debate can lead to what some might consider less democratic policies. But at least the processes that lead to these, and their purposes, and the procedures for challenging them, would be open and clear.

It might be read as an implication of the argument that runs throughout this book that the development of State patronage of the visual arts would be best served by the abolition of all quangos and the transfer of their powers back to the democratic forums of Parliament, County Councils and District Councils. I am not making that argument. In theory it is the obvious one. However, the national Parliament is too far removed from the minutiae of detail necessary in planning and implementing programmes appropriate to the visual arts. Moreover, given the relatively low level of public expenditure on the visual arts, the District and County Councils are in many ways too small to support the kinds of programmes and initiatives that might be useful.

If Wales and Scotland had devolved assemblies with real (rather than cosmetic) powers, and if the English regions similarly had their own parliaments, then these might be appropriate bodies through which to exercise a democratic control of arts policies in the areas now covered by arts councils, regional arts associations, the Crafts Council, area museum

111

councils, the Standing Commission on Museums and Galleries, the British Film Institute and other similar quangos. Moreover, at that level, integrated policies might be devised that brought together the work of all the above, with the work of art schools, museums of art, and other visual arts services run by District and County councils.

I am not suggesting that, if there were regional assemblies and Scottish and Welsh parliaments, that these would necessarily administer monolithic cultural departments; but they could usefully and sympathetically control the distribution and use of public expenditure in the arts, and they would be appropriate bodies to which arts organizations could be accountable.

With or without the development of regionally based democratic government, I would like to see the powers of the Arts Council in England devolved to the Engish regional arts associations, so that in terms of levels of expenditure and potential effectiveness they would become more like the Scottish and Welsh Arts Councils. Real devolution of powers and resources would not only enable those with initiative to develop more fully the positive things they are trying to do, but it would open up and allow for greater experiment, diversity and cross-fertilization of ideas and experiences.

Importantly, also, the more local organization would be more vulnerable to criticism and argument, and would have to justify itself more fully to its actual and potential publics. Vulnerability is an important characteristic of an open and democratic organization.

Whatever happens, however, debate and argument over the role and functions of State intervention in the visual arts are necessary. For in the last two hundred years much has happened in the sense of the accumulation of institutions and organizations; but little that has happened has had much todo with what a positive and creative art policy could be in a fully enfranchised and open democratic society in the late twentieth century.

# Notes and references

1. H. Osborne (1968) *Aesthetics and Art Theory*, London, Longmans, p. 60.
2. ibid. p. 21.
3. Raymond Williams (1976) *Keywords*, Glasgow, Fontana/Croom Helm.
4. idem.
5. Quoted in Clive Ashwin (1975) *Art Education, Documents and Policies*, London, Society for Research into Higher Education.
6. Instrument of Foundation of the Royal Academy of Arts in London: text reproduced in Sir Walter R. M. Lamb (1951) *The Royal Academy*, London, G. Bell and Sons, p. 193 ff. Also in C. Ashwin op.cit., p. 1 ff.
7. *see* Lamb, op.cit. p. 11.
8. ibid. p. 45.
9. Daniel Maclise, RA 1806–70, elected RA in 1840.
10. Royal Commission appointed 'to inquire into the present position of the Royal Academy in relation to the Fine Arts, and into the circumstances and conditions under which it occupies a portion of the National Gallery, and to suggest such measures as may be required to render it more useful in promoting art and in improving and developing public taste'. 1863 (3205) XXVII; 1863 (3205–1) XXVII; 1863 (3332) XIX. Maclise's statement, para 1411.
11. ibid. para. 1179, my italics.
12. ibid. para. 4208. Alexander James Beresford Hope lived 1820–87. Between 1841 and 1852 he was MP for Maidstone; 1857, re-elected; 1859, tried in vain for University of Cambridge seat, and in 1862 similarly failed at Stoke on Trent; 1865, became MP for Stoke, and, in 1868, MP for University of Cambridge, which seat he held till his death. An ardent church supporter, his interests included archaeology and ecclesiastical history. Between 1865 and 1867 he was President of the Royal Institute of British Architects; from 1879 he was a Trustee of the British Museum. He was also President of the Ecclesiological Society and of the Architectural Museum; and a Trustee of the National Portrait Gallery. An advocate of the Gothic principles in art, his publications include: *The Common Sense of Art*, (1858); *The Conditions and Prospects of Architectural Art*, (1863); and *The Art Workman's Position*, (1864).
13. Royal Commission on Academy, op.cit. para. 4225.
14. ibid. para. 4208.
15. ibid. para. 4244.
16. Sir Joshua Reynolds (1901) *Discourses*, p. 11. Note that the word 'design' as used by Reynolds in the eighteenth century conveyed a different meaning. It was 'conceptually related to the Italian *disegno*, meaning graphic invention in the fine arts and architecture, or the French *dessin* (drawing).' (Ashwin, C. *Art Education*, op.cit. p. 1.)
17. William Ewart, MP. 1798–1869. Barrister. Became MP for Bletchingly, Surrey, in 1828; 1830, became MP for Liverpool, his home town; re-elected 1831, 1832 and 1835; defeated, 1837; elected MP for Wigan in 1839, and in 1841 elected MP for Dumfries Burghs. Retired in 1868.
18. The Society for the Encouragement of Arts, Manufactures and Commerce; later to acquire the prefix, 'Royal'; now generally referred to as the Royal Society of Arts. On its history see G. K. Menzies (1935) *The Story of the Royal Society of Arts*, London, John Murray, this being an abridged and updated version of Sir Henry Trueman Wood's *Official History*.
19. Benjamin Robert Haydon. 1786–1846. A historical painter, born in Plymouth;

1822, petitioned Parliament to grant money for decoration of churches and other public buildings; 1834, petitioned for spaces for pictures on the walls of the new Houses of Parliament, this petition being approved; 1835, scheme for schools of design accepted by William Ewart's Select Committee on the same; lectured all over British Isles on art, art education and public art.

20. *see* J. Steegman (1970) *Victorian Taste*, London, Thomas Nelson and Sons, pp. 139−41.
21. Poulett Thomson (later, Lord Sydenham). 1799−1841. MP for Dover, 1826; MP for Manchester many times from 1832; President of Board of Trade from 1834; peerage, 1840.
22. *see* S. Macdonald (1970) *The History and Philosophy of Art Education*, London, University of London Press, p. 69.
23. ibid. p. 70.
24. quoted, ibid. p. 71.
25. On early history of the schools *see*; Macdonald, op. cit; Q. Bell (1963) *The Schools of Design*, London, Routledge and Kegan Paul; and the 1849 report of the Select Committee on Government Schools of Design.
26. From Introduction to the *Report of the Select Committee on Government Schools of Design*, 1849. My italics.
27. Burke (1756) *A Philosophical Enquiry into the Origins of our Ideas on the Sublime and the Beautiful*.
28. ibid.
29. quoted, Macdonald, op.cit. p. 151.
30. From evidence to Select Committee on Government Schools of Design, 1849, para. 690.
31. quoted Macdonald, op.cit. p. 84.
32. *Report of the Select Committee on Government Schools of Design*, p. iv.
33. Sir Charles Lock Eastlake, 1793−1865. Painter. Of many important positions held, the two most influential were: from 1850, President of the Royal Academy, and from 1855, Director of the National Gallery.
34. Royal Commission on Academy, op.cit. (see note 10) para 619.
35. ibid. para. 621.
36. 'South Kensington', where the London school was located.
37. Royal Commission on Academy, op.cit. para. 1013.
38. ibid. para. 1026.
39. ibid. para. 1027.
40. see note 18.
41. see H. Osborne, op.cit.; A. Martindale (1972) *The Rise of the Artist in the Middle Ages and Early Renaissance.*, London, Thames and Hudson; K. Baynes (1975) *Art in Society*, London, Lund Humphries.
42. As note 41; *see also* P. Burke (1972) *Culture and Society in Renaissance Italy*, London, Batsford; Jean Gimpel (1969) *The Cult of Art*, London, Wiedenfeld and Nicolson.
43. Benjamin Hawes, 1797−1862. MP from 1832−52, part of time for Lambeth, and part of time for Kinsale; retired as MP in 1852 to devote himself fully to being deputy secretary at War Department. 1857 became Permanent Under-Secretary at War Department. It was by his action in 1841 that the Royal Fine Arts Commission was set up; also due to him that the British Museum was opened on holidays.
44. Summarized in *Quarterly Journal of Education*, Vol X, 1835, pp. 284−306.
45. James Silk Buckingham, 1786−1855. Born in Flushing, near Falmouth.

Traveller, writer and lecturer. From 1832–37 was MP for Sheffield. 1834 appointment of Select Committee under his chairmanship to enquire into 'the extent, causes and consequences of the prevailing vice of intoxication among the labouring classes of the United Kingdom.' This concern with drink continued, Buckingham being President of the London Temperance League in 1851. He published eighteen books on travel and other matters; also two-volume biography.

46. A. Gramsci *Selections from the Prison Notebooks*. Edited and translated, Q. Hoare and G. N. Smith (1971) London, Lawrence and Wishart, p. 258.

47. quoted in T. Kelly (1973) *A History of Public Libraries in Great Britain*, London, the Library Association. Quotation taken from Hansard, Parliamentary Debates, 3rd Series, Vol XLVIII, 1839, col 91.

48. *see* J. Steegman (1970) *Victorian Taste*, London, Thomas Nelson and Son, pp. 207–8.

49. quoted in H. Cole (1884) *Fifty Years of Public Work*, London, George Bell and Sons, p. 165.

50. ibid.

51. Gramsci, see note 46.

52. reproduced in Cole, op.cit. Vol. 1, p. 391.

53. In 1899 the Department of Science and Art was merged with the Education Department to become the Board of Education; this, from 1944, became the Ministry of Education, and later still the Department of Education and Science.

54. quoted in *Victoria and Albert Museum Guide*, HMSO, 1960, p. 4.

55. 1864 Select Committee on Schools of Art, 1864 (466) XII, para. 4313.

56. from H. Cole op.cit. Vol. 2. p. 293.

57. ibid. p. 363.

58. idem.

59. ibid. p. 266.

60. ibid. p. 345.

61. ibid. pp. 290–1.

62. Reproduced in Cole, op.cit. Vol 2. Speech delivered 15 January 1873.

63. *see* J. Steegman (1936) *The Rule of Taste*, London, Macmillan.

64. As made before the Royal Commission on the Academy, see note 10.

65. see R. Williams op.cit., sections on 'Art', 'Aesthetics' and 'Taste'. It was during this period that 'art' became specialized and professionalized in its modern sense.

66. The Arts Council of Great Britain (1956) *The First Ten Years — Eleventh annual report*, London, Arts Council of Great Britain.

67. Numbers here refer to numbers of exhibitions; not numbers of showings, which was higher.

68. *see The Visual Arts*, a report by The Arts Enquiry, sponsored by the Dartington Hall Trustees, and published by Political and Economic Planning, with Geoffrey Cumberlage, Oxford University Press, 1946, p. 139.

69. ibid.

70. Listed on page 5 of *The Visual Arts*, op.cit.

71. ibid. p. 6.

72. ibid. p. 42.

73. ibid.

74. ibid. p. 43.

75. ibid. p. 44.

76. quoted in *The Visual Arts*, op.cit. p. 55.

77. Reprinted in *The Listener* 12 July 1945, and in Appendix A of the Arts Council of Great Britain's *First Annual Report* (London, Arts Council of Great Britain, 1946).

78. E. White (1975) *The Arts Council of Great Britain*, London, Davis Poynter, p. 241.

79. ibid.

80. *The Visual Arts*, op.cit. p. 35.

81. The Arts Council of Great Britain (1956) *The First Ten Years — Eleventh Annual Report*, London, Arts Council of Great Britain, p. 23.

82. Arts Council of Great Britain (1953) *The Public and the Arts — Eighth Annual Report*, London, Arts Council of Great Britain, p. 10.

83. ibid. p. 11.

84. as note 81, pp. 18–19.

85. quoted in E. White op.cit. p. 243.

86. The Arts Council of Great Britain (1957) *Art in the Red — Twelfth Annual Report*, London, Arts Council of Great Britain, p. 29.

87. Lord Bridges, *et al*, (1959) *Help for the Arts — a Report to the Calouste Gulbenkian Foundation*, London, the Calouste Gulbenkian Foundation, 1959, para. 43.

88. ibid. para. 64.

89. ibid. para. 65.

90. as note 78, p. 7.

91. as note 77, p. 21.

92. The Arts Council of Great Britain (1964) *State of Play — Nineteenth Annual Report*, London, Arts Council of Great Britain, p. 29.

93. The Arts Council of Great Britain (1961) *Partners in Patronage — Sixteenth Annual Report*, London, Arts Council of Great Britain, p. 9.

94. ibid. p. 8.

95. Cmnd 2601. For commentary on the paper see Appendix B to the 1966 revised edition of Raymond Williams' *Communications*, Chatto and Windus 1966, Penguin 1968.

96. as note 93, p. 7.

97. Hugh Willatt (n.d.) *The Arts Council of Great Britain — The First 25 Years*, London, The Arts Council of Great Britain, p. 15.

98. John Maynard Keynes, *The Arts Council — its policy and hopes*, broadcast 1945, and reprinted in: Arts Council of Great Britain *First Annual Report*, London, Arts Council of Great Britain, 1946.

99. R. Shaw, Summing up speech to 1974 Regional Studies Association conference on *The Arts in the Regions*, London, Regional Studies Association, 1974.

100. Lord Feversham 'The Role of the Regional Arts Associations', paper given to 1974 Regional Studies Association conference on *The Arts in the Regions*, London, Regional Studies Association, 1974.

101. The Arts Council of Great Britain (1977) *Value for Money — Thirty-Second Annual Report*, London, Arts Council of Great Britain, p. 15.

102. This is not the total of all art department schemes; for full listing of schemes see Arts Council of Great Britain annual reports, particularly Schedule 3 of accounts under 'Art'. See also the report produced from the Calouste Gulbenkian Foundation funded 'Enquiry into the Economic Situation of the Visual Artist', where Arts Council spending on and practices towards art are examined in detail.

103. Williams, R. 'The Arts Council', *Political Quarterly*, Vol. 50, No. 2, April/May/

June 1979.

104. ibid.

105. as note 97, p. 10.

106. The Arts Council of Great Britain (1967) *A New Chapter — Twenty-second Annual Report*, London, Arts Council of Great Britain.

107. Patrick Gibson, 'The Arts Council's Regional Policy', speech to 1974 Regional Studies Association Conference on *The Arts in the Regions*, London, Regional Studies Association, 1974.

108. The Arts Council of Great Britain (1966) *Key Year — twenty-first Annual Report*, London, Arts Council of Great Britain, p. 9.

109. *A Policy for the Arts — The First Steps*, London, HMSO, 1965, Cmnd 2601, para. 74.

110. ibid. para. 75.

111. ibid. para. 76.

112. idem.

113. idem.

114. ibid. para. 78.

115. E. White, op.cit. p. 73.

116. ibid. p. 74.

117. Norman St John Stevas, 'The Tories and the Arts', in *The Observer*, 14 October 1979.

118. ibid.

119. ibid.

120. Gillian Clarke, in 'Editorial' of *Anglo – Welsh Review*, Tenby, The Five Arches Press, No. 66, 1980, p. 3.

121. Raymond Williams, *Welsh Culture*, talk given on BBC Radio 3, 27 September 1975, and reprinted in: Plaid Cymru (1975) *Culture and Politics — Plaid Cymru's Challenge to Wales*, Cardiff, Plaid Cymru.

122. p. 15.

123. R. Shaw (1978) *Elitism Versus Populism in the Arts*, London, City University, p. 6.

124. p. 10. The Arts Council of Great Britain (1976) *The Arts in Hard Times — Thirty-first Annual Report*, London, Arts Council of Great Britain.

125. p. 6. The Arts Council of Great Britain (1979) *Patronage and Responsibility — Thirty-fourth Annual Report*, London, Arts Council of Great Britain.

126. as note 123, p. 4.

127. John Maynard Keynes in 1945 BBC Home Service talk on *The Arts Council: its Policy and Hopes*, reproduced in: The Arts Council of Great Britain (1946) *First Annual Report*, London, the Arts Council of Great Britain.

128. *see* Raymond Williams, op.cit. See under 'Standards'.

129. ibid.

130. as note 127.

131. But see, for an interesting and radical questioning of State museums of art, a paper by Tom Sutcliffe 'The Collection of Art' in *The Collection of Art* published by the Welsh Arts Council with the Department of Extra Mural Studies, University College of Wales Aberystwyth, 1981.

132. *see*: N. Pearson 'Art Schools and the Un-Publicness of Art', in *The Teaching of Art — the Roots of Self-Deception*, pub. by Welsh Arts Council with the Department of Extra-Mural Studies, University College of Wales Aberystwyth, 1981.

# Bibliography

ALBERT, Harold A. (1963) *The Queen and the Arts,* London, W. H. Allen.

ALEXANDER, David (1978) *A Policy for the Arts: Just Cut Taxes,* London, Selsdon Group.

ALLAN, Lewis. (1976) 'Patronage in Perspective', in *Art and Patronage,* Aberystwyth, Department of Extra Mural Studies, University College of Wales, and the Welsh Arts Council.

ALLSOPP, Bruce. (1959) *The Future of the Arts,* London, Pitman.

ARNOLD, Matthew (n.d.) *Culture and Anarchy,* London, Thomas Nelson and Sons.

Artists Now (publisher) (n.d.) *Patronage and the Creative Artist,* London.

Artists Union (publisher) (1977) *Why Do Artists Need a Union?* London.

Artlaw Research Project (publisher) (1977) *The Visual Artist and the Law,* London.

Arts Canada (publisher) (1975) *The Canadian Cultural Revolution — an appraisal of the politics and economics of art,* Toronto.

The Arts Council of Great Britain (publisher) *Annual Reports,* 1946–79, London.

The Arts Council of Great Britain (publisher) *Housing the Arts in Great Britain,* London, 2 Vols, 1961 and 1969.

The Arts Council of Great Britain (publisher) (1974) *Community Arts,* London.

The Arts Enquiry (1946) *The Visual Arts — a Report Sponsored by the Dartington Hall Trustees,* London, published on behalf of 'The Arts Enquiry' by PEP, and Geoffrey Cumberlage, Oxford University Press.

ASHWIN, Clive (1975) *Art Education: Documents and Policies,* London, Society for Research into Higher Education.

ATKINSON, Frank (1975) 'Remember What Happened to the Dinosaurs?' Presidential address to the Museums Association conference, London, Museums Association.

BAXANDALL, L. (1972) *Radical Perspectives in the Arts,* Harmondsworth, Penguin.

BELL, Q. (1963) *The Schools of Design,* London, Routledge and Kegan Paul.

BISHOP, A. S. (1971) *The Rise of a Central Authority for English Education,* Cambridge, Cambridge University Press.

BLAUG, Mark (ed.) (1976) *Economics of the Arts,* London, Martin Robertson and Co.

BRIDGES, Lord (1958) *The State and the Arts,* Oxford, Clarendon Press.

BRIDGES, Lord, *et al.* (1959) *Help for the Arts — a Report to the Calouste Gulbenkian Foundation,* London, Calouste Gulbenkian Foundation.

BRIGHTON, A. (1977) 'Official Art and the Tate Gallery', *Studio International,* 1977, No. 1.

British Information Services (publisher) (1944) *Entertainment and the Arts in Wartime Britain,* London.

BROUGH, Colin (1977) *As You Like It; Private Support for the Arts*, London, Bow Publications.

BROWN, F. P. (1912) *South Kensington and its Art Training*, London, Longman, Green and Co.

BURKE, E. (1756) *A Philosophical Enquiry into the Origins of our Ideas on the Sublime and the Beautiful.*

BURKE, Peter (1972) *Culture and Society in Renaissance Italy, 1420–1540.* London, Batsford.

BURNHAM, Bonnie (1975) *The Art Crisis*, London, Collins.

BUXTON, H. J. Wilmot, and POYNTER, E. J. (1881) *German, Flemish and Dutch Painting*, in series Poynter E. J. (ed.) *Art Textbooks*, London, Sampton, Low, Marston, Searle and Rivington.

CALDER, Angus (1969) *The People's War: Britain 1939–45.* New York, Pantheon Books.

CARLESS, Richard and BREWSTER, Patricia (1959) *Patronage and the Arts*, London, Conservative Political Centre, for the Bow Group.

Central Office of Information (1975) *The Promotion of Arts in Britain.* London, HMSO, 2nd ed.

Central Youth Employment Executive (1971) *Choice of Careers; 103, Art and Design*, London, HMSO, 3rd ed.

CLARK, Kenneth (1974) *Another Part of the Wood*, London, Book Club Associates.

COCKS, Barnett (1977) *Mid-Victorian Masterpiece — the Story of an Institution Unable to Put its Own House in Order*, London, Book Club Associates.

COLE, Henry (1884) *Fifty Years of Public Work*, London, George Bell and Sons.

College Art Association (1966) *The Visual Arts in Higher Education*, Yale, Yale University Press.

Conservative Party (1962) *Government and the Arts*, London, Conservative Political Centre.

Conservative Political Centre (publisher) (1978) *The Arts — The Way Forward*, London.

COX, Ian (1951) *The South Bank Exhibition — a Guide to the Story it Tells*, London, HMSO.

Crafts Advisory Committee (publisher) (1974 and 1977) *The Work of the Crafts Advisory Committee*, two separate publications, one for 1971–4, and one for 1974–7, London.

Dartington Hall Trustees: see under Arts Enquiry.

DAVIES, C. J. (1974) 'The New Local Authorities and the Arts', paper to 1974 Regional Studies Association conference on *The Arts in the Regions*, London, Regional Studies Association.

DAVIES, Peter (1978) 'Problems of RAAs', *Art Monthly*, No. 15, London, Britannia Art Publications.

de BEER, G. R. (1953) *Hans Sloane and the British Museum*, Oxford, Oxford University Press.

DEMARCO, Richard (1978) *The Artist as Explorer*, Edinburgh, The Richard Demarco Gallery Edinburgh Arts.

Department of Education and Science Annual Reports, titled, *Education and Science in . . .,* followed by year, London, HMSO.

Department of Education and Science (1973) *Provincial Museums and Galleries — a report of a Committee appointed by the Paymaster General,* London, HMSO.

Department of Extra Mural Studies, University College of Wales and The Welsh Arts Council (n.d.) *Art and Patronage,* Conference Papers.

Department of the Environment (1975) *Sport and Recreation,* Cmnd. 6200, London, HMSO.

DICK, Stewart (1927) *More Hours in the National Gallery,* London, Duckworth.

DIGGLE, Keith (1976) *Marketing the Arts,* London, Centre for Arts and Related Studies, City University, London.

DORMER, Peter (1977) 'Splendours and Miseries of Local Government Patronage' *Art Monthly,* No. 13, 1977/78, London, Britannia Art Publications.

DORMER, Peter (1978) 'Splendours and Miseries of Local Government Patronage, 2' *Art Monthly,* No. 15, 1978, London, Britannia Art Publications.

DORMER, Peter (1978) 'Splendours and Miseries of Local Government Patronage' *Art Monthly,* No. 18, 1978, London, Britannia Art Publications.

DREW, Joanna (1980) 'The Arts Council: Galleries, Exhibitions and the Public Beyond', Joanna Drew interviewed by Richard Cork, *Studio International* Vol. 195, No. 990, 1/1980.

ELIAS, Norbert (1970) *African Art,* Leicester, Leicester Museums.

ELLIS, S. (1975) 'Ewart, Haydon, and the Select Committee . . . 1835 – 36'. *History of Education Society Bulletin,* No. 15, pp. 15 – 23.

EMMERSON, Sir Harold (1956) *The Ministry of Works,* London, George Allen and Unwin.

EVANS, B. Ifor and GLASGOW, Mary (1949) *The Arts in England,* London, The Falcon Press.

FARR, Dennis (1976) 'Connoisseurship and the Curator', *Museums Journal,* Vol. 75, No. 4 March 1976. London, The Museums Association.

Federation of British Craft Societies (1977) *Income Tax and the Craftsman,* London, Federation of British Craft Societies.

FEVERSHAM, Lord (1974) *The Role of Regional Arts Associations,* a paper from Regional Studies Association 1974 Conference, London, Regional Studies Association.

FULLER, Peter (1976) 'Hugh Jenkin's Rule — What did the former Minister for the Arts Achieve?' *Art Monthly,* No. 2, 1976. London, Britannia Art Publications.

GIBSON, Patrick (1974) 'The Arts Council's Regional Policy', Speech to Regional Studies Association 1974 Conference, London, Regional Studies Association.

GIMPEL, Jean (1969) *The Cult of Art: against art and artists,* London, Weidenfeld and Nicolson.

GIRARD, Augustin (1972) *Cultural Development: Experience and Policies,* Paris, UNESCO.

GLASGOW, Mary 'State Aid for the Arts', *Britain Today,* June 1951, pp. 6–15.

GLOAG, John (1972) *Victorian Taste,* Newton Abbot, David and Charles.

GOLDBERG, J. (1974) 'The Arts and Regional Development', Speech to Regional Studies Association Conference, 1974. London, Regional Studies Association.

GRAMSCI, Antonio (1971) *Selections from the Prison Notebooks,* edited and translated by HOARE, Quintin, and SMITH, Geoffrey Nowell, London, Lawrence and Wishart.

Great Exhibition (1851) *Official Descriptive and Illustrated Catalogue of the Great Exhibition,* 3 Vols.

GREEN, M. & WILDING, M. (1970) *Cultural Policy in Great Britain,* Paris, UNESCO.

GREYSER, Stephen A. (ed.) (1973) *Cultural Policy and Arts Administration,* Harvard, Harvard Summer School Institute in Arts Administration.

HANNEMA, Sjoerd (1970) *Fad, Fakes and Fantasies — the Crisis in Art Schools and the Crisis in Art,* London, Macdonald.

HARRIS, John S. (1970) *Government Patronage of the Arts in Great Britain,* London & Chicago, University of Chicago Press.

HARRISON, B. (1968) 'Two Roads to Social Reform: Francis Place and the Drunken Committee of 1834', *Historical Journal,* Vol XI, Cambridge.

HARRISON, J. F. C. (1961) *Learning and Living,* London, Routledge and Kegan Paul.

HARRISON, Molly (1973) *Museums and Galleries,* London, Routledge and Kegan Paul.

HARVIE, C. *et al.* (1970) *Industrialisation and Culture: 1830–1914,* London & Basingstoke, Macmillan for the Open University Press.

HAUSER, A. (1962) *The Social History of Art,* London, Routledge and Kegan Paul.

HAWORTH, J. T. and VEAL, A. J. (eds) (1976) *Leisure and the Community,* Birmingham, published for the Leisure Studies Association, by the University of Birmingham.

Her Majesty's Government *A Policy for the Arts: the Arts; the First Steps,* Cmnd. 2601. London, HMSO.

Her Majesty's Government (1971) *Future Policy for Museums and Galleries,* Cmnd. 4676, London, HMSO.

Her Majesty's Stationery Office (pub.) (1958) *Government and the Arts in Britain,* London HMSO.

HOBSON, G. B. (n.d.) *Art After the War,* London, B. T. Batsford.

HOLMES, Sir Charles (1937) *National Gallery Illustrated Guide,* London, National Gallery.

HONEYMAN, T. J. (1971) *Art and Audacity,* London & Glasgow, Collins.

HUDSON, Kenneth (1975) *A Social History of Museums,* London, Macmillan.

HUTCHINSON, R. (1974) *Fund Raising from the Private Sector — the Experience of the Regional Arts Associations,* ACGB Research Bulletin No.

3, London, Arts Council of Great Britain.

HUTCHINSON, Robert (1975) *Survey of Visual Artists — their Incomes and Expenditures and attitudes to Arts Council Support,* ACGB Research Bulletin No. 4, London, Arts Council of Great Britain.

HUTCHINSON, Robert (1977) *Three Arts Centres,* London, Arts Council of Great Britain.

HUTCHISON, Sidney (1968) *History of the Royal Academy,* London, Chapman and Hill.

JENKINS, Hugh (1974) untitled. Speech made by the Minister for the Arts to the Regional Studies Association Conference in 1974. London, Regional Studies Association.

JENKINS, Hugh (1978) 'Decision Making and Democracy in the Arts', *Art Monthly,* No. 16, 1978, London, Britannia Art Publications.

KAINES SMITH, S. C. (1932) *Art and Commonsense,* London, Medici Society.

KEEN, Geraldine (1971) *The Sale of Works of Art,* London, Nelson.

KELLY, Thomas (1973) *A History of Public Libraries in Great Britain* London, the Library Association.

KEYNES, J. M. (1936) 'Art and the State', *The Listener,* 26 August 1936 London, BBC.

KEYNES, J. M. (1945) 'The Arts Council: its policy and hopes', *The Listener* 12 July 1945 and reproduced in the Arts Council's *First Annual Report* in 1946 London, BBC and London, Arts Council of Great Britain.

KING, Karen, and BLAUG, Mark (1975) 'Does the Arts Council Know What it is Doing?' *Encounter,* September 1975.

KIRKHAM, Hazel (1981) *The Welsh Arts Council's Visual Art Development Project 1979 – 1981,* Cardiff, Welsh Arts Council.

KLINGENDER, F. D. (1972) *Art and the Industrial Revolution,* London, Paladin.

Labour Party (1975) *The Arts: a discussion document for the Labour Movement,* London, The Labour Party.

Labour Party (1977) *The Arts and the People: Labour's Policy Towards the Arts,* A 'policy background paper'. London, Labour Party.

LAMB, Sir Walter. R. M. (1951) *The Royal Academy,* London, G. Bell and Sons.

LEA, J. T. (1968) 'The History and Development of Mechanics' Institutes', *Research in Librarianship,* October 1968.

LEWES, F. M. M. and MENNEL, S. J. (1976) *Leisure, Culture and Local Government — a study of policies and provision in Exeter,* Exeter, University of Exeter.

LINDSAY, Jack (n.d.) *British Achievement in Art and Music,* A wartime survey. London, Pilot Press.

LISTENER (1940) 'Artists in War and Peace', *The Listener* 11 January 1940.

MACDONALD, Stuart (1970) *The History and Philosophy of Art Education,* London, University of London Press.

MACY, Christopher (1971) *The Arts in a Permissive Society,* London, Pemberton Books.

MAO TSE TUNG (1967) *Five Documents on Literature and Art,* Peking,

Foreign Lanaguages Press.

MARKHAM, Sydney Frank (1938) *A Report on the Museums and Galleries of the British Isles (other than the National Museums) to the Carnegie United Kingdom Trust,* Dunfermline, Carnegie United Kingdom Trust.

MARSHALL, A. H. (1974) *Local Government and the Arts,* Birmingham, Institute of Local Government Studies.

MARTINDALE, A. (1972) *The Rise of the Artist in the Middle Ages and Early Renaissance,* London, Thames and Hudson.

MASSE, H. J. (1935) *Art Worker's Guild,* Oxford, Shakespeare Head Press.

MENZIES, G. K. (1935) *The Story of the Royal Society of Arts,* an abridged and updated version of Sir Henry Trueman Wood's *Official History,* London, John Murray.

MEYER, Karl (1973) *The Plundered Past — the traffic in art treasures,* Hamish Hamilton.

MIDDLEMAS, Keith (1975) *The Double Market,* Gordon Cremonesi.

MIERS, Henry (1928) *A report on the Public Museums of the British Isles (other than the National Museums) to the Carnegie United Kingdom Trustees,* Edinburgh, Carnegie United Kingdom Trust.

MILLER, E. J. (1976) *A Brief History of the British Museum,* London, Pitkin Pictorials.

MILLS, John F. (1973) *Treasure Keepers,* London, Aldus Books: Jupiter Books.

MINIHAN, Janet (1977) *The Nationalisation of Culture — the Development of State Subsidies to the Arts in Great Britain,* London, Hamish Hamilton.

MOONMAN, Eric and ALEXANDER, D. *Business and the Arts,* London, Foundation for Business Responsibilities.

MOULIN, Raymonde (1976) *Public Aid for Creation in the Plastic Arts,* Oslo.

National Art Collections Fund (publisher) *Annual Reports,* London.

National Art Collections Fund (publisher) (1928) *Twenty-five Years of the National Art Collections Fund. 1903 – 1928,* London.

National Gallery *National Gallery, Millbank, Illustrated Guide, British School.*

Open University (publisher) (1976) *Art and Everyday Life,* Milton Keynes.

Open University (publisher) (1976) *The Great Divide — The Social Division of Labour, or "Is It Art?"* Milton Keynes.

Open University (publisher) (1976) *Social Relationships in Art,* Milton Keynes.

Open University (publisher) (1977) *Art and Political Action,* Milton Keynes.

OSBORNE, Harold (1968) *Aesthetics and Art Theory: an Historical Introduction,* London, Longmans.

PEARSON, L. F. (1976) 'Working Class Non-Work Time and Social Policy' in HAWARTH and VEAL (ed.) *Leisure and the Community,* Birmingham, Centre for Urban and Regional Studies, University of Birmingham.

PEARSON, N. (1981) *Art Galleries and Exhibition Spaces in Wales,* Cardiff, Welsh Arts Council.

PEARSON, N. (1981) 'Art, Socialism and the Division of Labour' in *The Journal*, William Morris Society.

PEARSON, N. (1981) 'Art Colleges and the Un-Publicness of Art' in *Art Teaching — The Roots of Self-Deception?* Cardiff, Welsh Arts Council with the Department of Extra-Mural Studies University College of Wales Aberystwyth.

PEARSON, N. (1980) *Art Colleges, Art History and the Training of Artists*, discussion paper, Cardiff, Welsh Arts Council.

PEARSON, N. and BRIGHTON, A. (1978) 'The Specialness of Art and Artists', *Art Monthly* No. 21, London.

PEARSON, Richard (1866) *Popular Taste*, Glasgow, Porteus Brothers.

PEVSNER, N. (1940) *Academies of Art, Past and Present*, Cambridge, Cambridge University Press.

PHILLIPS, Anthony (1977) *The Arts in the Scottish Regions*, Edinburgh, Scottish Arts Council.

PICK, John (ed) (1980) *The State and the Arts*, London, City Arts.

POLLITT, J. J. (1972) *Art and Experience in Classical Greece*, Cambridge, Cambridge University Press.

POLLITT, J. J. (1974) *The Ancient View of Greek Art*, London and Yew Haven, Yale University Press.

POYNTER, Edwart J. and HEAD, P. R. (1885) *Classic and Italian Painting*, in series, POYNTER, E. J. (ed.) *Art Text Books*, London, Sampson, Low, Marston, Searle and Rivington.

PRIESTLY, J. B. (1974) *Victoria's Heyday*, Book Club Associates by arrangement with Heinnemann.

PYE, David (1971) *The Nature and Art of Workmanship*, London, Studio Vista.

READ, H. (1936) *Art and Society*, London, Heinnemann.

READ, H. (1936) *The Meaning of Art*, London, Faber and Faber, 2nd ed. reprint.

READ, H. (1936) *Painting and Sculpture*, London, Faber and Faber, 2nd revised edition.

READ, H. (1943) *Education Through Art*, London, Faber and Faber.

READ, H. (1944) *Art and Industry: the Principles of Industrial Design*, London, Faber and Faber, 2nd Edition.

READ, H. (1963) *To Hell with Culture, and Other Essays on Art and Society*, London, Routledge and Kegan Paul.

REDCLIFFE-MAUD, Lord J. (1976) *Support for the Arts in England and Wales*, London, Calouste Gulbenkian Foundation.

REYNOLDS, Sir Joshua (n.d.) *Fifteen Discourses Delivered to the Royal Academy*, London, J. M. Dent & Co., Everyman Library.

RICHARDS, Charles C. (1922) *Art in Industry*, New York.

RIPLEY, Dillon (1970) *The Sacred Grove; Museums and their Evolution*, London, Victor Gollancz.

RITCHIE, Jane (1972) *The Employment of Art College Leavers*, London, H.M.S.O.

ROBINSON, Kenneth, and FULLER, Peter (1978) 'Kenneth Robinson on Arts

Council Policy', *Art Monthly*, No. 15, 1978. London, Britannia Art Publications.

Royal Society of Arts (1935) *The Story of the Royal Society of Arts*, London, John Murray.

Royal Society of Arts (publisher) *The Royal Society of Arts*, 24-page booklet, London.

ROYLE, E. (1971) 'Mechanics' Institutes and the Working Classes: 1840–1860', *The Historical Journal*, Vol XIV, No. 2.

RUCK, S. K. (1965) *Municipal Entertainment and the Arts in Greater London*, London, George Allen and Unwin.

RUSKIN, John (1893) *A Joy for Ever*, London, George Allen.

RUSKIN, John (1904) *The Ethics of the Dust*, London, George Allen.

RUSKIN, John (1904) *Time and Tide*, London, George Allen.

RUSKIN, John (1904) *The Queen of the Air*, London, George Allen.

RUSKIN, John (1904) *The Two Paths*, London, George Allen.

RUSKIN, John (1905) *Sesame and Lilies*, London, George Allen.

RUSKIN, John (1927) *Readings in Modern Painters*, London, George Allen and Unwin.

RUSKIN, John (n.d.) *The Seven Lamps of Architecture*, London, J. M. Dent & Co.

RUSSELL, Gordon (1953) *Furniture*, Harmondsworth, Penguin Books, first pub. 1947.

SECRETARIAT D'ETAT A LA CULTURE (1976) *Public Aid to Creative Art in France*, Paris.

SHANGHAI WRITING GROUP FOR REVOLUTIONARY MASS CRITICISM (1971) *To trumpet Bourgeois Literature and Art is to Restore Capitalism*, Peking, Foreign Languages Press.

SHAW, Roy (1974) *Summing Up Speech* to 1974 Regional Studies Association Conference on arts in the regions, London, Regional Studies Association.

SHAW, Roy (1976) 'Arts for the People', in *Art and Patronage*, Aberystwyth, Department of Extra Mural Studies, University College of Wales, Aberystwyth and The Welsh Arts Council.

SHAW, Roy (1978) *Elitism versus Populism in the Arts*, London, City University.

SMITH, H. L. (1924) *The Economic Laws of Art Production*, Oxford, Oxford University Press.

SMITH, Roger (1890) *Architecture, Gothic and Renaissance*, in series, POYNTER, E. J. (ed.) *Art Textbooks*, London, Sampson, Low, Marston, Searle and Rivington.

SNOOKS, G. D. (1977) *Personal Income Distribution and its Determinants; the Australian Visual Arts Profession*, Working Paper Series, No. 22, Institute of Labour Studies, Flinders University of South Australia.

SNOOKS, G. D. (1978) *The Economic and Social Experience of Australian Artists in the mid 1970s*, in series, *Flinders Working Paper in Economic History*, No. 1, Flinders University of South Australia.

Standing Commission on Museums and Galleries (1948) *The National Museums and Galleries — the War Years and After*, 3rd report of the

Standing Commission on Museums and Galleries, London, H.M.S.O.

Standing Commission on Museums and Galleries (1963) *Survey of Provincial Museums and Galleries,* London, H.M.S.O.

STEEGMAN, John (1936) *The Rule of Taste,* London, Macmillan.

STEEGMAN, John (1970) *Victorian Taste,* London, Thomas Nelson & Sons.

STURT-PENROSE, Barrie (1969) *The Art Scene,* London and New York, Paul Hamlyn.

SUTTON, G. (1967) *Artisan or Artist,* Pergamon Press.

THOMPSON, Colin (1972) *Pictures from Scotland: the National Gallery of Scotland and its Collection: a study of the changing attitude to painting since the 1820s,* Edinburgh, Trustees of the National Gallery of Scotland.

THOMPSON, Denys, (ed) (1964) *Discrimination and Popular Culture,* Harmondsworth, Penguin.

Trades Union Congress (1976) *The Arts — a TUC Consultative Document,* London, TUC.

TYRWHITT, Rev St John (1868) *Handbook of Pictorial Art,* Oxford, Clarendon Press.

UNESCO (1969) *Cultural Policy — a Preliminary Study,* Paris, UNESCO.

UNESCO Studies in *Cultural Policy* series. UNESCO publishes a large number of books on cultural policy in various countries of the world. Each book under the title *Cultural Policy in . . .* followed by the name of the country. Published by UNESCO, Paris, and available in English.

VENTURI, Lionello (1964) *History of Art Criticism,* trans. Marriott, C., (New York, E. P. Dutton.

Victoria and Albert Museum (1976) *The History of the Victoria and Albert Museum,* London, H.M.S.O.

VON HOLST, Niels (1967, 1976) *Creators, Collectors and Connoisseurs — the anatomy of artistic taste from antiquity to the present day,* London, Thames and Hudson, 1967; London, Book Club Associates, 1976.

WATSON, V. (1973) *The British Museum,* London, Quartet Books.

WHITE, Eric, W. (1975) *The Arts Council of Great Britain,* London, Davis Poynter.

WILLATT, Hugh (n.d.) *The Arts Council of Great Britain — the first 25 years,* London, Arts Council of Great Britain.

WILLIAMS, Raymond (1965) *The Long Revolution,* Harmondsworth, Penguin.

WILLIAMS, Raymond (1976) *Keywords: A Vocabulary of Culture and Society,* Glasgow, Fontana/Croom Helm.

WOLFF, Janet (1975) *Hermeneutic Philosophy and the Sociology of Art,* London, Routledge and Kegan Paul.

WOLLHEIM, Richard (1970) *Art and its Objects,* Harmondsworth, Penguin.

WRAIGHT, Robert (1968) *Hip! Hip! Hip! RA,* London, Leslie Frewin.

WRAIGHT, Robert (1975) *The Art Game Again,* Newton Abbot, Reader's Union.

WRIGHT, C. W. (Chairman) (1973) *Provincial Museums and Galleries — a report of a committee appointed by the Paymaster General,* London, H.M.S.O.

# INDEX